Plexi Class

cutting-edge projects in plastic

Tonia Davenport

NORTH LIGHT BOOKS
CINCINNATI, OHIO
www.mycraftivity.com

12 11 10 09 08 5 4 3 2 1

Distributed in Canada by Fraser Direct
100 Armstrong Avenue
Georgetown, ON, Canada L7G 5S4
Tel: (905) 877-4411

Distributed in the U.K. and Europe by David &
Charles
Brunel House, Newton Abbot, Devon, TQ12 4PU,
England
Tel: (+44) 1626 323200, Fax: (+44) 1626 323319
E-mail: postmaster@davidandcharles.co.uk

Distributed in Australia by Capricorn Link
P.O. Box 704, S. Windsor, NSW 2756 Australia
Tel: (02) 4577-3555

Library of Congress Cataloging-in-Publication Data

Davenport, Tonia
 Plexi class : cutting-edge projects in plastic / by
Tonia Davenport.
 p. cm.
 Includes index.
 ISBN 978-1-60061-061-5
 1. Plastics craft. I. Title.
TT297.D34 2008
745.57'2--dc22

 2007041239

Metric Conversion Chart

TO CONVERT	TO	MULTIPLY BY
Inches	Centimeters	2.54
Centimeters	Inches	0.4
Feet	Centimeters	30.5
Centimeters	Feet	0.03
Yards	Meters	0.9
Meters	Yards	1.1
Sq. Inches	Sq. Centimeters	6.45
Sq. Centimeters	Sq. Inches	0.16
Sq. Feet	Sq. Meters	0.09
Sq. Meters	Sq. Feet	10.8
Sq. Yards	Sq. Meters	0.8
Sq. Meters	Sq. Yards	1.2
Pounds	Kilograms	0.45
Kilograms	Pounds	2.2
Ounces	Grams	28.3
Grams	Ounces	0.035

fw
F+W PUBLICATIONS, INC.
www.fwpublications.com

Editor: Jessica Strawser
Designer: Marissa Bowers
Production Coordinator: Greg Nock
Photographers: Christine Polomsky;
John Carrico, Adam Leigh-Manuell, Adam
Henry, Alias Imaging, LLC
Stylist: Lauren Emmerling

dedication

To my North Light family, who trusted in me and my ideas enough to let me do this book.

acknowledgments

Many thanks to many people who helped me get these projects, and this book, together. Dave at TAP Plastics, Drew at Beadalon, John at Dremel and the creative folks at Stewart Superior—you all provided me with some great inspiration.

Production thanks goes to my top-notch editor, Jessica Strawser; world-class designer, Marissa Bowers; renowned photographers, Christine Polomsky and the team at Alias Imaging, LLC; and outstanding production coordinator, Greg Nock. It's the entire team that makes a book great.

about the author

Tonia Davenport is a mixed-media artist and the acquisitions editor for North Light Craft. Her first book, *Frame It!* came after ten years of professional picture framing, which gave Tonia a lot of experience working with Plexiglas. She teaches workshops incorporating this medium and has been featured on HGTV's *That's Clever*.

contents

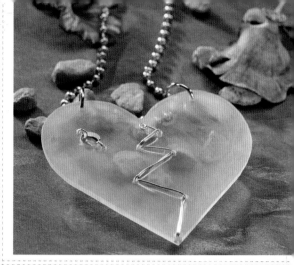

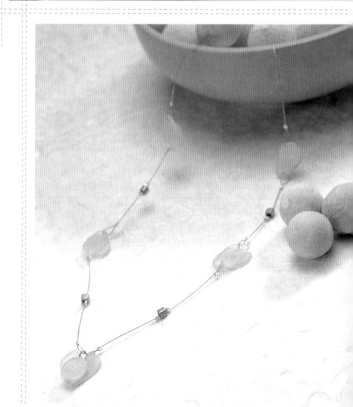

Plexi Accessories 68

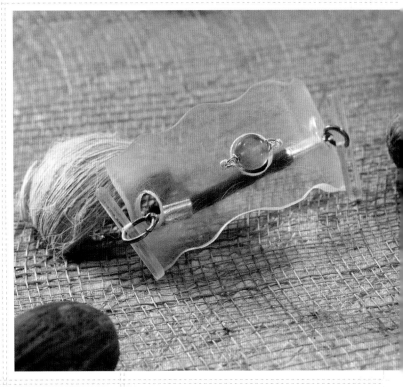

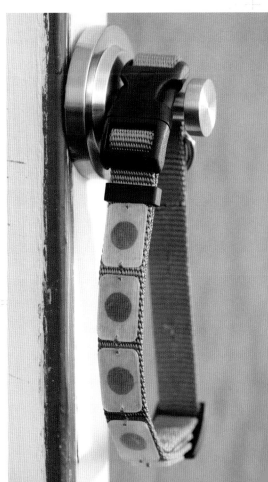

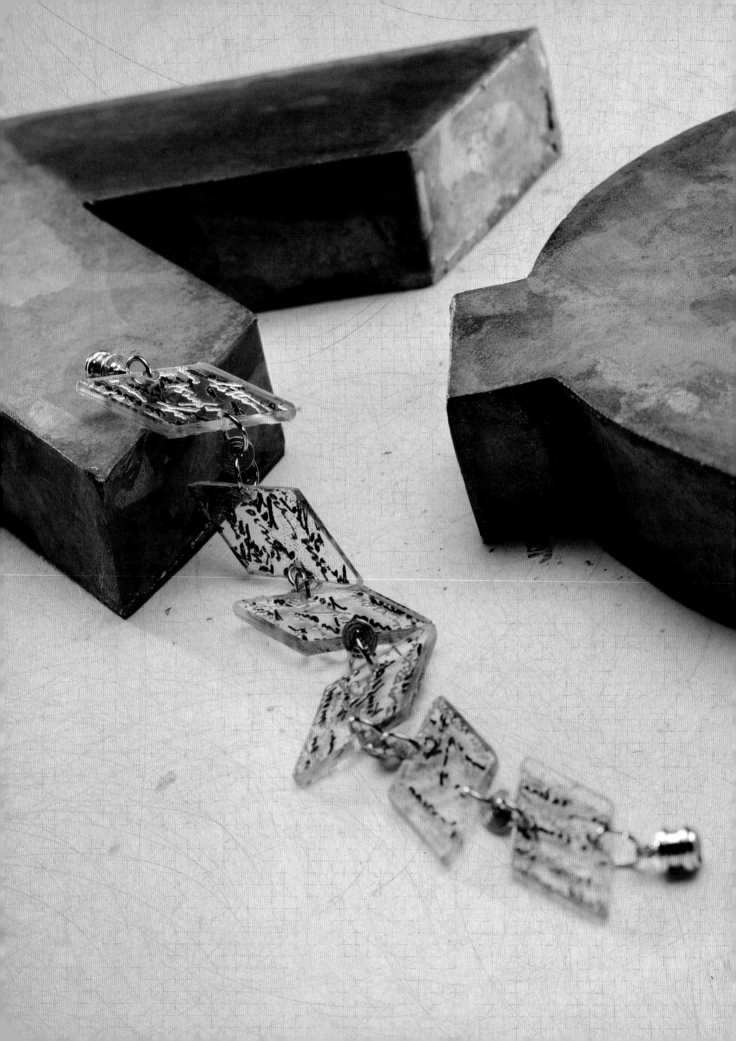

Introduction

I think I have been more inspired by Plexiglas than by just about any other material. Ever. I am aware that by making this declaration, I am setting myself up to instantly be labeled as a geek, someone who really needs to get out more or is just plain weird—but don't be too quick to judge. If you have purchased this book or, at the very least, picked it up off of the shelf, you, too, must at least be curious about the possibilities presented by Plexiglas, if not secretly fascinated yourself.

I'm naturally a minimalist at heart, and I think that is one reason I love the aesthetic of Plexiglas. At its core, it's a barely there, nonintrusive material that stands out only as much as you want it to. Few materials are as versatile to work with as Plexiglas. You can sand it, drill through it, cut it, glue it, sculpt it or heat and form it. It's durable and lightweight and, unlike glass, it breathes, so it's safe to sandwich directly on top of photographs without the fear of the dreaded condensation-stick.

I was not very well versed in the discipline of jewelry making until I started playing around with Plexiglas. Now, I think it will be quite some time until I'll be able to give it up. As a result of my experimentation, most of the projects in this book center around adornment—but I couldn't resist using it for other things, such as the box purse (see page 94), hair accessories (see pages 70-76) and even a nightlight (see page 120). Then of course, there's one of the best reasons for using Plexiglas—the reason I was aware of its seductive properties in the first place—for creative framing solutions (see pages 110 and 114 for two of my favorite examples). And despite the title of this book, I didn't limit myself to just Plexiglas—I broadened the reach of these projects to include other types of plastics, as well, such as shrink plastic and vinyl.

Once you see how easy and even forgiving to work with Plexiglas is, I hope you'll be inspired to push its boundaries yourself and come up with plastic creations of your own. Are you ready to get started? Class is officially in session ...

materials

If you are a crafter, you probably already have many of the supplies we'll be using in this book. Think of Plexiglas both literally and figuratively as a blank canvas. Many of the things you can do to a canvas, you can do to Plexiglas: apply gel medium, layer on papers, stamp, you name it. Here on these pages, you'll find an overview of the materials we'll be using in this book, but don't limit yourself to what's mentioned here. Experiment!

Plexiglas!

Just as paper, paint and jewelry materials come in different sizes and levels of quality, so does acrylic sheeting, more commonly known as Plexiglas or Lucite. While the star of our show is available in thicknesses as thin as $\frac{1}{16}$" (2mm), the projects in this book all use pieces that are about $\frac{1}{8}$" (3mm) thick. This thickness is sturdy enough to take a beating, but thin enough to cut easily.

Acrylic that is manufactured for picture framing is typically the highest quality available to the average consumer. Obviously, you can always find this at frame shops, and sometimes it is sold at hardware stores, too. Available in regular, nonglare and UV-resistant, this grade of plastic provides the greatest clarity and is often the most durable.

The acrylic you'll find on the other end of the scale is the least expensive variety. For most small projects and especially those that you'll be coating with paper, the inexpensive grade is acceptable. One thing I've noticed with "cheap" plastic is that it doesn't break quite as cleanly when you're cutting it (it's a bit softer and more flexible), but on the flip side, it's easier to heat and shape than acrylic of a higher quality.

I recommend starting with whatever you can find at your local hardware store, and as your skills improve (along with your standards), try out some of the better-quality grades from a plastics dealer or a frame shop and get to know the difference and the place for each in your work. When I want the Plexiglas to remain clear, I tend to prefer picture-frame grade, but when I'm planning on sanding it or bending it, a lower grade is fine.

Shrink Plastic

There are a few different manufacturers of the product we remember making Shrinky Dinks out of as children. Today, this magical plastic is available in clear, frosted, black and white, and it even comes in ink-jet-compatible sheets you can custom print yourself. Package directions usually say to bake the product in the oven, but I typically use my heat gun. (If you are particular about the piece maintaining a perfect shape, stick to the manufacturer's instructions.)

Clear Vinyl

This material is like pliable Plexiglas. While it's used only a couple of times in this book, I love using vinyl to create sleeves and pockets because you can sew on it. You can also achieve some interesting effects by distressing it with sandpaper.

Plastic Cement

This glue is actually a solvent that melts two pieces of plastic together. It works on Plexiglas, shrink plastic and vinyl. The best joints are made on Plexiglas by holding the desired two pieces together and brushing the glue along the seam, letting the solvent be "sucked in" by capillary action. You can find this glue in hobby stores; I prefer the Plastruct brand. Be sure to always use this glue in a well-ventilated area, as it is toxic.

Tissue Paper

Tissue paper can be adhered to Plexiglas to give it color, as well as a look of heightened dimension and texture. Because it absorbs gel medium and adheres to the acrylic surface best, I prefer tissue paper that is not smooth, but textured and fibrous.

Gel Medium

Golden products are my personal preference for acrylic mediums because they seem to dry the most clearly.

Stamping Ink

I have had great luck with the staying power of Super Marking Ink by Stewart Superior. Waterproof and scratch resistant, these inks are fairly permanent. Cleanup must be done with a solvent.

Embossing Powder

The staying power of this powder after it's melted on Plexiglas is fairly good, though not 100 percent permanent. When applying heat with a heat gun, be sure to not hold the heat too close or in one area for too long, or the Plexiglas will begin to warp.

Beads and Jewelry Findings

Use what inspires you. Sometimes I design an entire project around a single bead. Bead selection is highly personal, so use whatever speaks to you. Because Plexiglas is neutral by nature, it's easy to adapt any of the projects in this book to work with your own choices.

Jump rings, magnetic clasps, fish-hook style ear wires, wire earring hoops, silver-colored copper-filled wire, coated wire and ribbon crimps are all basic findings that you should be able to locate at your local craft store in the beading section. I rarely use any wire other than 18-, 20-, 22- and 24-gauge, and I prefer Beadalon wire because I find it easy to manipulate.

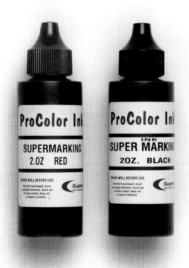

tools

Ah, the world of tools. Excuse the cliché, but I couldn't agree more that having the "right tool for the right job" can cut your frustration tenfold. I use four primary tools for working with Plexiglas: a plastic cutter, a rotary tool, a drill press (though any drill will do) and a hot knife. A brief discussion of each, in addition to a few others, follows. And don't be afraid of power tools—they give you power!

Plastic Cutter

The name of this tool is a little deceiving. It does not actually cut Plexiglas, it merely scores it so that you can break it. I have purchased plastic cutters in the acrylic sheet aisle of my local hardware store, and I can tell you that they may work for some people, but I wouldn't trade my Fletcher ScoreMate for anything in the world. In six years of regularly working with Plexiglas, I have gone through only two of these tools; they work forever.

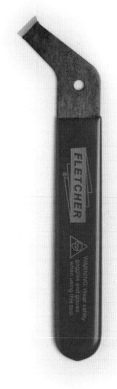

Rotary Tool

While you can sand Plexiglas with sandpaper, a rotary tool shaves a ton of time off of your efforts. My tool of choice is a cordless Dremel tool. Typically, I use the same sanding bit for about 90 percent of my work, but there are so many attachments available for this tool that it's priceless to have at hand. Did I mention that it also cuts things like wire and even bolts? Who wouldn't love that?

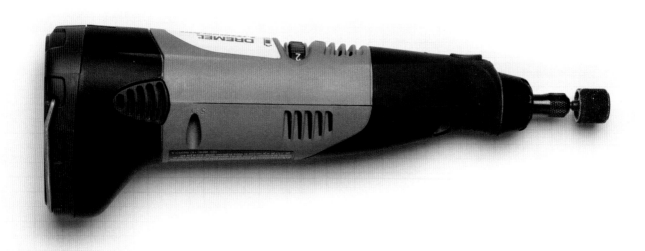

Drill

A drill is required for the majority of projects in this book, and while a hand drill will certainly suffice (it's all I use when teaching workshops, so I know it can be done), a power drill or drill press will make your life a bit easier. The most important bit for function is a $\frac{1}{16}$" (2mm), but for aesthetic's sake, a variety of larger bits will allow you to make groovy circles in your Plexiglas. Plexiglas heats up when it's being drilled (even by hand), so take care to stop if you see your bit getting gummed up with plastic shavings—forcing the shavings through the hole may result in cracks.

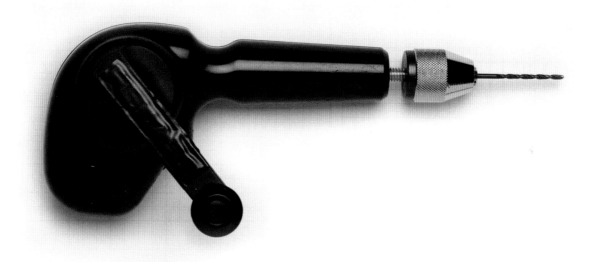

Sandpaper

It's a good idea to keep a variety of grades at hand. Finer grades are used for removing excess decorative paper from the Plexiglass, while courser grades can more quickly shape and dull edges. I prefer paper sheets for sanding entire sides of a piece of Plexiglas and sanding blocks for removing paper.

Hot Knife

Sometimes trying to score a small, narrow piece of Plexiglas with a plastic cutter and a straightedge can be a challenge. A hot knife is a heat tool with interchangeable bits, and I use the craft knife bit for melting a small line in little pieces of Plexiglas, allowing me to snap it easily and cleanly. Keep in mind that the hot knife takes a bit of time to heat up, so plug it in a few minutes before you'll be ready to cut.

Heat Gun

This comes in handy for quickly and easily shrinking shrink plastic, and it's a necessity for heating Plexiglas that you wish to bend or form. You can also use a heat gun to melt embossing powder. For heating Plexiglas, I recommend a step up from a standard stamping heat tool, as the cheapest models don't get quite as hot as an industrial model or my personal choice, the Milwaukee.

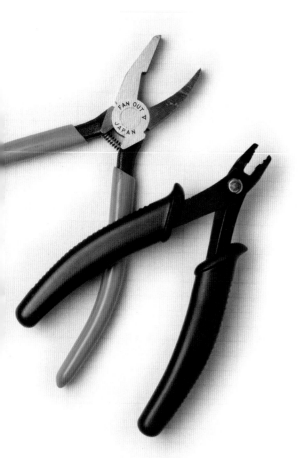

Jewelry Pliers and Cutters

For the wirework required in a few of this book's projects, only a small number of tools is recommended. You'll want to have a pair of round-nose pliers for creating loops and coils, a pair of needle-nose pliers for opening and closing jump rings, a pair of nylon-jawed pliers for grasping wire that you don't wish to mar, a pair of wire cutters and, if possible, a pair of flush cutters, for making nice, flush cuts on the wire.

Rubber Stamps

A few projects in this book call for adding stamped images to your Plexiglas, but even then, it's optional. The Super Marking Ink that's recommended for use on Plexi is best suited for less detailed stamps.

Brushes

When covering larger pieces of Plexiglas with paper, you can avoid the appearance of brushstrokes by dabbing gel medium on the surface with a foam brush. When working on smaller pieces, a regular flat paintbrush works fine.

Brayer

Nothing beats this tool for really getting paper down smoothly on a piece of gel-medium-covered Plexiglas, though it's really necessary only for larger pieces.

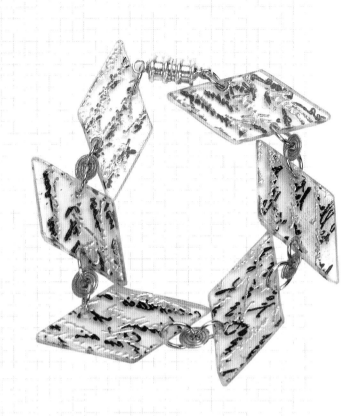

Plexi Pointers

> When using a brayer to smooth tissue paper over Plexiglas, you may find that the tissue so absorbant that gel medium will soak through and transfer to your brayer. Remember to rinse it off as soon as you're done.

Plexi 101:
Techniques for Working with Plexiglas

If you can use a ruler, you can work with Plexiglas. The same basic techniques are applied over and over again for every project—measure, mark, score, break, sand, shape and drill. While small power tools make things a breeze, hand tools can be used just as effectively. Plexi is forgiving, but it does have its limits so take your time and enjoy the process.

Cutting Sheets

If you are new to cutting Plexiglas, start with a thickness no larger than $\frac{1}{16}$" (2mm) to make breaking easier.

1 ›› **Measure and mark Plexiglas**
Measure and mark where you want to cut the Plexiglas. Permanent marker works best because it doesn't smear, and you don't need to worry about the permanence since at this stage you are marking on the clear protective cover that will be peeled off later.

2 ›› **Line up score line**
Lay a metal, cork-backed straightedge over the marks, and firmly press your plastic cutter right up against the straightedge.

3 ›› **Score marked line**
Using the straightedge as a guide, score the same spot a few times until you have established a deep groove. Then continue to score the line until you've scored it a total of about 5 times.

4 ›› **Break Plexiglas along scored line**
Line up the score line with the edge of a table, press the Plexiglas firmly onto the surface with one hand, and break it cleanly along the score line with the other.

5 ›› **Cut protective cover**
Bend the Plexiglas back the other way to slightly stretch the protective cover across the gap. Cut the protective cover apart.

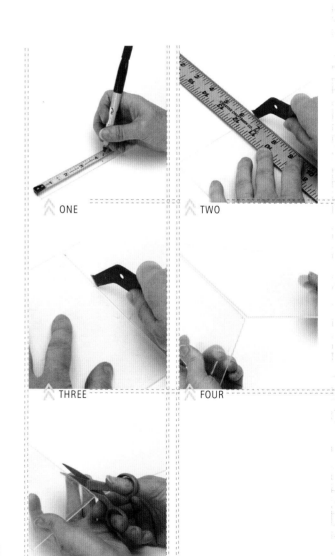

ONE

TWO

THREE

FOUR

FIVE

Plexi Pointers

›› Using a metal, cork-backed straightedge keeps the straightedge from slipping on the Plexiglas.

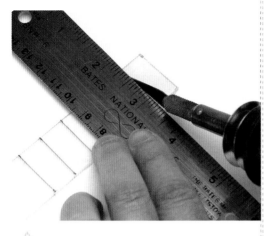

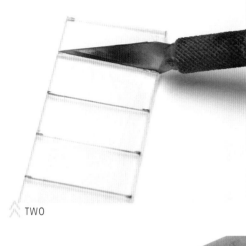

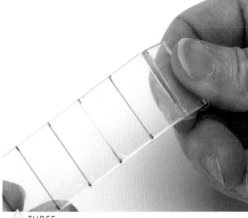

Precision Cutting

This method of cutting Plexiglas works well for small cuts, as when making jewelry or other detailed projects. Usually when I am cutting Plexiglas for jewelry, I'll need several pieces, so I cut them all from the same strip at one time.

1›› Measure, mark and score with hot knife

Measure where you want to cut the Plexiglas and mark your cut lines with a permanent marker. Lay a metal, cork-backed straightedge over the 2 marks, and use a hot knife to apply moderate scoring pressure along the cut line.

2›› Reinforce groove

A hot knife works by melting and cutting the plastic at the same time, so you'll need to score the plastic using the straightedge only once. Freehand run the knife along the groove again to ensure that the score line is firm.

3›› Break Plexiglas along score line

Use your hands to break the piece of plastic where it has been scored.

Distressing

I often like to sand Plexiglas before using it in my projects to give it tooth and a frosted look. If you're going to be adhering paper to the Plexiglas, you should sand it with a fine-grit sandpaper. If you're going to be using it by itself, you can use a sandpaper that's as coarse as you like. The more coarse your sandpaper is, the less transparent the Plexiglas will become. I like using sanding blocks, which come in different grits, but you can use a loose sheet of sandpaper if you prefer.

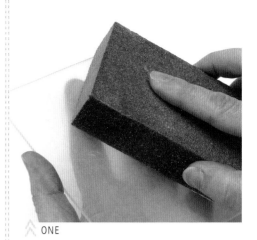

ONE

1›› Sand surface of Plexiglas
Peel the backing off of both sides of your piece. Holding the Plexiglas in your hand, use a circular motion to sand both sides of the plastic.

Smoothing Edges

Plexiglas edges can be a bit sharp, so I almost always smooth them for inclusion in my projects. Below, this technique is illustrated using a Dremel tool, but you can also smooth edges by hand with sandpaper—it just takes longer. Rotary tools like the Dremel tool are also great for shaping Plexiglas; you can use them to create grooves and other decorative effects.

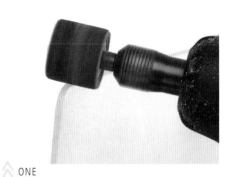

ONE

1›› Smooth corners with Dremel tool
Insert the round sandpaper attachment into your Dremel tool. Be sure to wear safety glasses to avoid getting pieces of plastic dust in your eyes. Turn the Dremel tool on, and work it back and forth around each of the 4 corners to smooth and round them.

2›› Smooth sides of Plexiglas
Continue to run the Dremel tool down the flat sides of the Plexiglas to smooth the hard corners. You can do this as much or as little as you like until you create the effect you are going for.

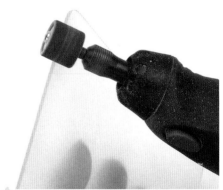

TWO

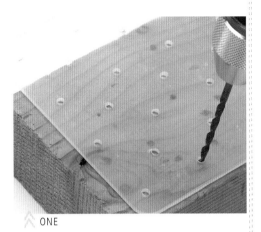

Drilling

Drilling holes through Plexiglas is not only functional but fun. The biggest key to success is patience. Rather than trying to drill a ¼" (6mm) hole from the get go, start with no larger than a ⅛" (3mm) bit and work your way up.

1 ›› Drill hole through plastic

Depending on the size and shape of your project, you may need a drill press or a clamp to properly drill your project. But for a simple flat piece of at least a few square inches (centimeters) you can simply use a hand drill to drill holes directly through the plastic. As the bit is working, it heats up the plastic enough to melt the waste that comes off the bit, so stop periodically to clear the shards away. This keeps them from gumming up your bit, which will prevent cracking of the surface.

ONE

Adhering Decorative Paper

When selecting paper to adhere to Plexiglas, look for very thin varieties such as tissue (sewing tissue is fun!), mulberry paper, rice paper, coffee filters or newsprint (such as recycled phonebook pages and newspaper).

1 ›› Apply coat of gel medium

Use a brush to apply gel medium to the entire sanded surface of your Plexiglas.

ONE

2 ›› Adhere tissue paper

Firmly place the Plexiglas gel-medium-side-down onto a piece of fibrous tissue paper.

TWO

3 ›› Brayer surface

Roll a brayer over the paper surface to ensure there are no air bubbles or wrinkles. (If your project is small, you can simply do this with your fingers.) Brush another coat of gel medium carefully over the entire brayered surface and let it dry.

THREE

4 ›› Sand excess paper from edges

Use a fine-grit sandpaper to sand the excess paper from the edges until they are clean and the adhered paper is flush with the plastic.

FOUR

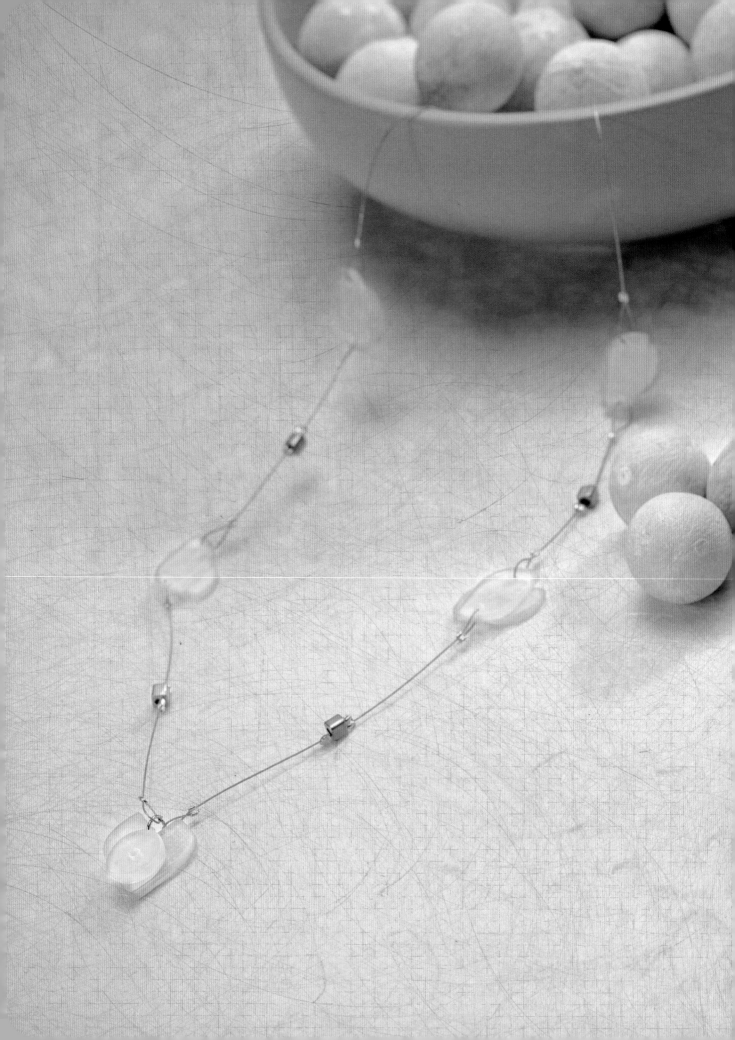

Plexi Jewelry

The combination of Plexiglas and jewelry making

is a match made in Heaven. I like wearing things I've created, but I don't like to be weighed down. All of the projects in this book are extremely lightweight, yet durable enough to endure your most hectic days. But the weight factor isn't the only reason I love PlexiJewelry. The real fun is in the design and the making.

Plexiglas is a beautiful foundation for jewelry. It can catch the light and sparkle, or absorb it and almost disappear, depending on the angle and whether or not the Plexiglas is sanded or left shiny. Sanded, it can accept paint and paper, allowing plenty of opportunity for expression. Left clear, it can protect your most treasured sentiments while putting them proudly on display. Although it is durable, it is easily sanded to make it smooth, to soften sharp corners and to create interesting curves and shapes. And its colorlessness makes it suitable to use with any of your favorite beads or findings.

Once you discover how many things you can make with Plexiglas, I hope you'll be anxious to start designing your own pieces. Don't be afraid to push the plastic in new directions. Just don't forget to wear your safety glasses while you're pushing!

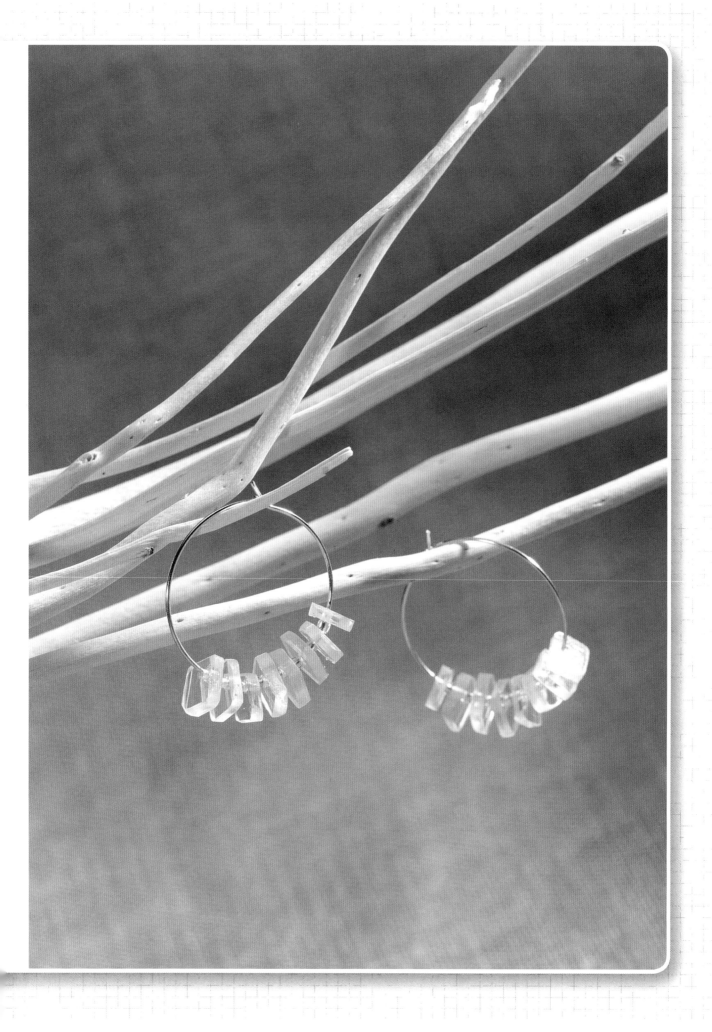

over ice earrings

These are the optimal versatile earrings: They match absolutely everything (and garner lots of compliments, too). If you like this look of glass chips but want to add a little color to your project, try using colored seed beads in lieu of these clear ones—you could try an understated pale green or perhaps mix multiple colors. If you'd prefer yours straight up instead of over ice, try adhering colorful tissue papers to the Plexiglas chips after you drill them for added flavor.

materials

16 irregular squares of Plexiglas measuring from $^3/_{16}$" (5mm) to $^5/_{16}$" (8mm)

2 silver wire hoop earrings

14 clear seed beads

fine-grit sandpaper or Dremel tool with sanding attachment

hand drill

$^1/_{16}$" (2mm) drill bit

round-nose pliers

1›› Prepare and arrange components

Use fine-grit sandpaper or a Dremel tool with a sanding attachment to smooth the edges and round the corners of the small Plexiglas squares. Using a hand drill and a $^1/_{16}$" (2mm) bit, drill a hole near the center of each piece, but don't worry about the holes being exactly in the center—random positioning will add to the irregularity of the earrings. Divide the materials into 2 piles: 8 pieces of Plexiglas and 7 clear seed beads for each earring. Line up all of the components the way they will go onto the hoops, beginning with a Plexiglas piece for each earring and then alternating seed beads with the Plexiglas pieces.

2›› Construct earrings

Thread all of the components onto the earring hoop. Use pliers to create a slight bend at the end of the hoop so it will fasten more easily.

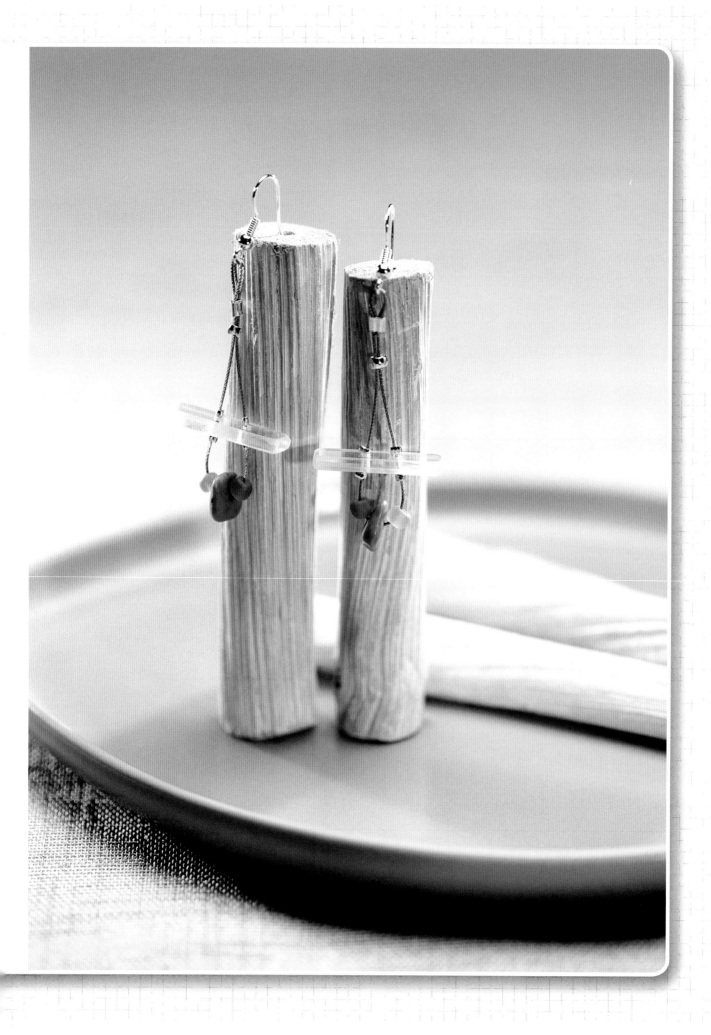

flight plan earrings

For some reason, these earrings remind me of a bird or a plane; I guess it's because of the horizontal, wing-like Plexiglas. Needless to say, just about any beads at all would work with this concept—and crimp beads allow you to assemble the complete pair at Mach speed.

materials

2 pieces $^5/_{16}$" x 1" (8mm x 3cm) of Plexiglas	2 #4 crimp tubes (Beadalon)	fine-grit sandpaper or Dremel tool with a sanding attachment
2 focal faux turquoise beads	2 #3 crimp beads (Beadalon)	hand drill
4 smaller orange glass beads	8 #1 crimp beads (Beadalon)	$^1/_{16}$" (2mm) drill bit
2 hook earring findings	wire cutters	ruler or measuring tape
10" (25cm) .024" nylon-coated wire	crimping pliers	

1›› Plan earring construction

Use fine-grit sandpaper or a Dremel tool with a sanding attachment to smooth the edges of both Plexiglas pieces. Make 2 marks in the center of each piece, ¼" (6mm) apart. With a $^1/_{16}$" (2mm) drill bit, drill through each of these marks. Arrange the earring components in a design that's pleasing to you.

2›› Thread elements on wire

Cut 2 5" (13cm) lengths of wire. To create each earring: Thread the beads onto the wire. About ¼" (6mm) to the left of the beads, crimp a #1 crimp bead onto the wire using crimping pliers. Repeat to the right of the beads. Thread the ends of the wire through the holes in the Plexiglas piece so it rests on the crimp beads.

3›› Crimp wire ends together

Crimp a #1 crimp bead onto each wire just above the Plexiglas piece. Gather the wires together in a teardrop shape, leaving about $^5/_8$" (2cm) of bare wire on each side, and crimp them with a larger #3 crimp bead.

4›› Finish earring

Thread the crimp tube onto both wires. Holding the wires together, thread them through the hook earring finding and back through the tube. Use crimping pliers to crimp the tube closed and to hold the top of the earring in place. With wire cutters, trim any excess wire.

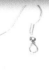

ONE

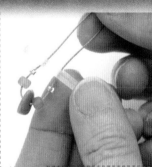

TWO

THREE

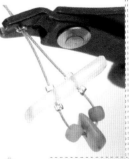

FOUR

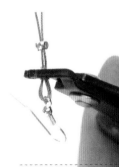

23

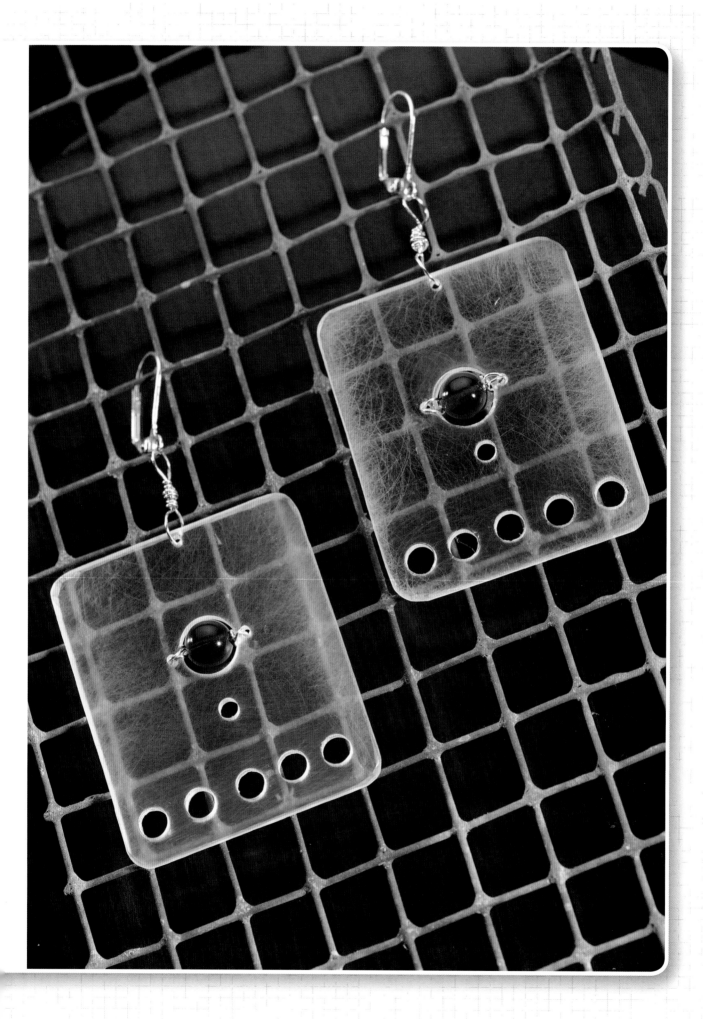

solo exhibition earrings

Dramatic in their size, yet simple in design, these earrings are easy to create with one exception: deciding on a color for the single, suspended bead that will be on exhibit. Even fans of delicate earrings will love to try these less understated creations. The pair is surprisingly light, even though their weight looks substantial. To make them a bit lighter still, simply modify the pattern so it has more holes in it. Your ears will feel as if they're floating on air.

materials

2 1¾" × 2" (4cm × 5cm) pieces of Plexiglas
approx 10" (25cm) silver-colored 22-gauge wire
2 8mm red glass beads
2 clasp earring findings
hand drill
³/₈" (1cm), ³/₁₆" (5mm), ¹/₈" (3mm) and ¹/₁₆" (2mm) drill bits
graph paper
assorted circular templates
fine-grit sandpaper
marker
Dremel tool with sanding attachment (optional)
wire cutters
pliers
pencil

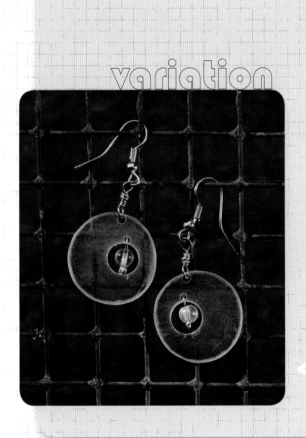

variation

« *Use your Dremel tool to shape circles from small squares for a more understated look.*

1›› Prepare Plexiglas and plot design

Use fine-grit sandpaper to sand both sides of the Plexiglas pieces. Use sandpaper or a Dremel tool to round all the corners and smooth all the edges. Trace around the sanded pieces of Plexiglas on a piece of graph paper. Remove the Plexiglas and use the grid along with circular templates to plot out the design you would like to drill into your earrings. In the earrings shown, the red glass bead is the focal point, so the circle for the glass bead is slightly larger than the diameter of the bead itself. Use a marker to trace the design onto the Plexiglas.

2›› Drill holes and begin to wire bead

Drill through each of the holes marked on 1 of the pieces of Plexiglas. To create the larger central hole, start with a small bit and work your way up to the ³⁄₈" (1cm) bit for the central hole. Use the ¹⁄₁₆" (2mm) bit for the holes to the right and left of the bead and the hole for the ear wire at the top, the ¹⁄₈" (3mm) bit for the hole below the red bead and the ³⁄₁₆" (5mm) bit for the holes across the bottom. Cut a length of wire to approximately 5" (13cm) and thread it through the bead. Thread one end of the wire through the hole on the right from the front to the back, and the other end of the wire through the hole on the left from the back to the front.

3›› Continue to wire focal bead into earring

Wrap the lengths of wire, still in opposite directions, through the hole that contains the bead. Wrap each length of wire around itself once, and pull taut. Thread each end of wire back through its respective hole to the front and left of the bead.

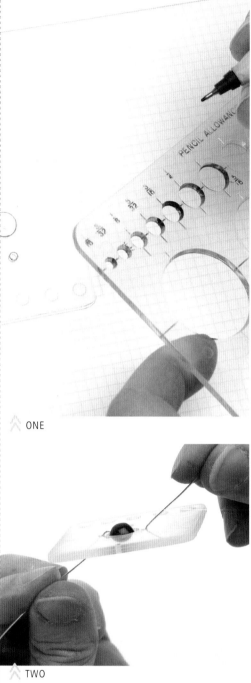

⚞ ONE

⚞ TWO

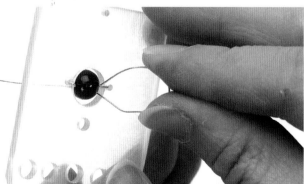

⚞ THREE

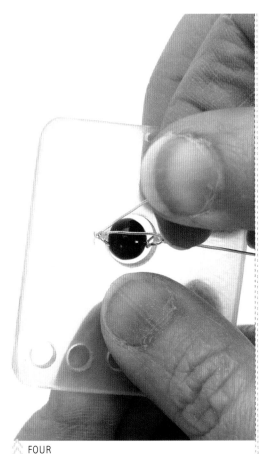

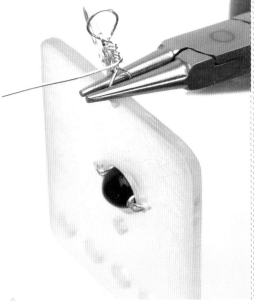

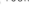
FOUR

FIVE

4›› Secure bead

Wrap each end around the wire adjacent to the bead again and use wire cutters to trim off the ends. Use pliers to press any sharp edges flush against the Plexiglas.

5›› Attach earring finding to the top

Cut a length of wire to approximately 5" (13cm), and loop the wire around the pliers approximately 1" (3cm) from one end of the wire. Thread the earring finding onto the loop, then wrap the short end of the wire around the base of the loop as many times as you can. Wrap the wire around the pliers to create another loop, then thread the wire through the top center hole and slide the earring down onto the loop. Grasp the top of the loop in the pliers and wrap the length of wire several times around the wire just above the earrings. Trim away any excess wire. Repeat steps 2–5 to form the second earring.

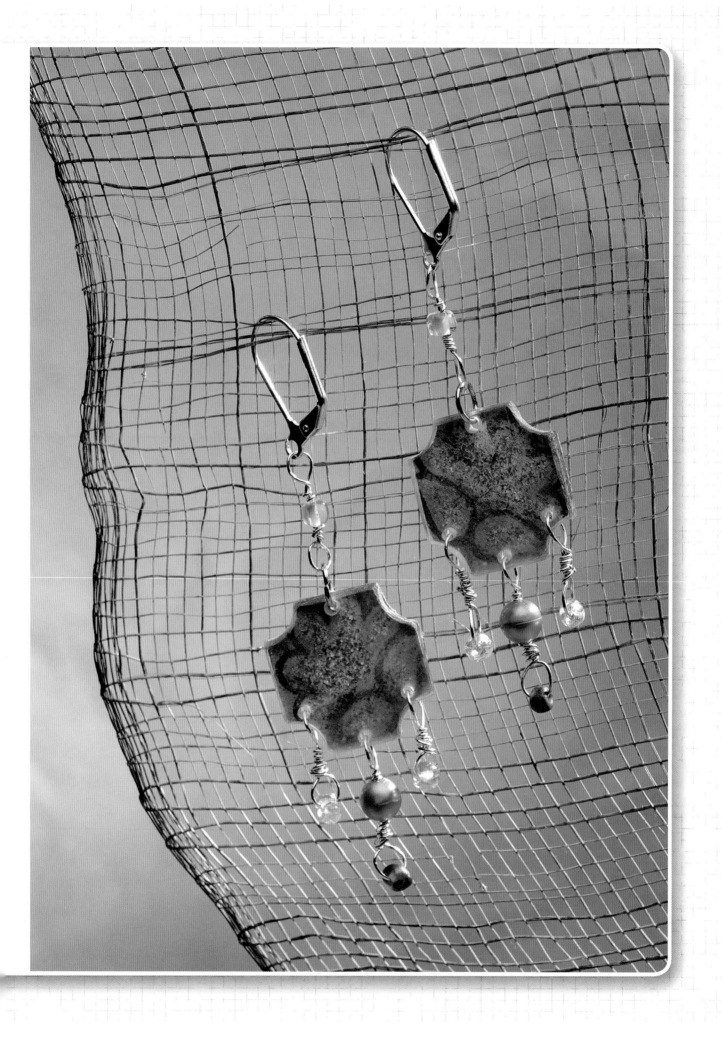

top-notched earrings

All that glitters may not be gold, but any glitter is definitely still top-notch in my book. The decorative paper used for these earrings came with glitter on it, but you could always add a bit of sparkle to plain paper yourself.

materials

2 $^7/_8$" (2cm) Plexiglas squares	2 jump rings	round-nose pliers
decorative paper, slightly larger than the Plexiglas squares	paintbrush	hand drill
	fine-grit sandpaper	$^1/_{16}$" (2mm) drill bit
approx 2' (61cm) 22-gauge wire	Dremel tool with sanding attachment	fine-point pen
10 small assorted beads		matte medium
2 clasp earring findings	wire cutters	

1›› Create Plexiglas charms

Use fine-grit sandpaper to sand 1 side of each Plexiglas square. Brush matte medium onto the sanded sides and press them onto decorative paper. Work out any wrinkles or air bubbles, apply another coat of matte medium, and let it dry. Sand off excess paper. With a Dremel tool and sanding attachment, notch each corner.

2›› Drill holes and plan design

With a fine-point pen, mark the top and bottom center of each charm, $^1/_{16}$" (2mm) from the edge. Mark $^1/_8$" (3mm) from the right side of the earring and $^1/_{16}$" (2mm) from the edge of the corner notch. Repeat on the other side. With a $^1/_{16}$" (2mm) bit, drill through each mark. Arrange the earring components around the holes until you create a construction you like.

3›› Create top portion of each earring

Clamp the wire with pliers 1" (3cm) from the end, wrap it around the pliers to make a loop, and thread on the clasp. Wrap the short end of the wire around the wire beneath the loop a few times. Trim any excess. Thread on a bead, leave a bit of space, then wrap the wire around the pliers again, then around itself a few times just above this loop. Trim any excess. Use a jump ring to attach the bottom loop to the top hole of the charm. With pliers, attach the clasp earring finding to the top loop. Repeat for the second earring.

4›› Create bead and wire dangles

To create the 2 side dangles of each earring: Thread the wire through the charm, wrap it around the pliers to make a loop, and slide the loop into the hole. Wrap the wire around itself beneath the loop several times. Thread on a bead, and use the pliers to make a loop beneath it. Wrap the wire around itself a few times just above this loop. Trim any excess. To create the center dangles: Follow the same steps, but allow for the addition of the focal bead as shown.

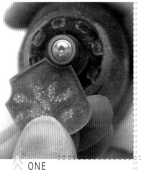

ONE

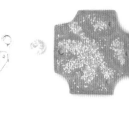

TWO

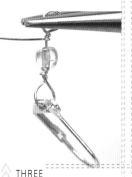

THREE

FOUR

29

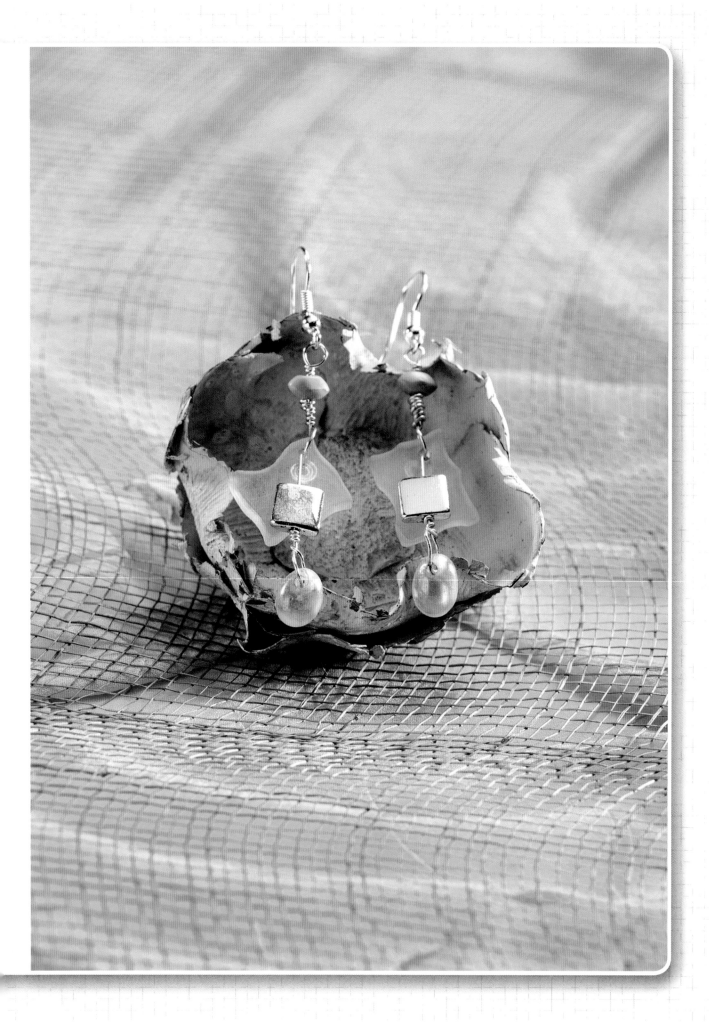

beachcomber earrings

Reminiscent of combing for sea glass on the beach, these earrings have a natural oceanside aesthetic that makes them perfect for summer and sundresses. The free-form Plexiglas shape looks just like glass worn beautifully smooth by the sands of time; the silver bead reminds me of an old fishing lure that has washed ashore.

materials

2 pieces ⁵/₈" × ½" (2cm × 1cm) Plexiglas	wire cutters
approx 10" (25cm) 22-gauge silver-colored wire	round-nose pliers
2 small faux turquoise beads	Dremel tool with sanding attachment
2 clear glass drop beads	hand drill
2 square silver beads	¹/₁₆" (2mm) drill bit
2 hook earring findings	
fine-grit sandpaper	

1 ›› Prepare components

Sand both sides of the Plexiglas pieces with fine-grit sandpaper. Using the Dremel tool and the sanding attachment, round the corners and carve little circular waves around the perimeter of each piece. With a ¹/₁₆" (2mm) bit, drill an off-center hole near the top short end of each piece of Plexiglas. Arrange the main components of the earring in a construction you like.

2 ›› Wire earring together

Place pliers about 1" (3cm) from one end of a 5" (13cm) length of wire, and twist the wire around the tip of the pliers to form a small loop. Thread a clear glass drop bead onto the loop, then wrap the short end of the wire around the top of the loop as many times as you can, being sure to squeeze the sharp end down. Thread the square silver bead onto the wire, and leaving a length of about ¼" (6mm) of wire, thread the wire through the hole in the Plexiglas. Coil the remaining wire into a spiral and press it flush against the back of the plastic to hold the dangle firmly in place. Place your pliers about 1½" (4cm) from one end of another 5" (13cm) length of wire, and again form a small loop. Thread the piece of Plexiglas onto the loop. Secure it with a wire wrap as before. Thread on a faux turquoise bead, leave about ⅛" (3mm) and create another loop in the wire with your pliers. Thread the hook finding onto this loop. Wrap the end of the wire around the wire just above the turquoise bead as many times as you can. Repeat for the second earring.

⌃ ONE

⌃ TWO

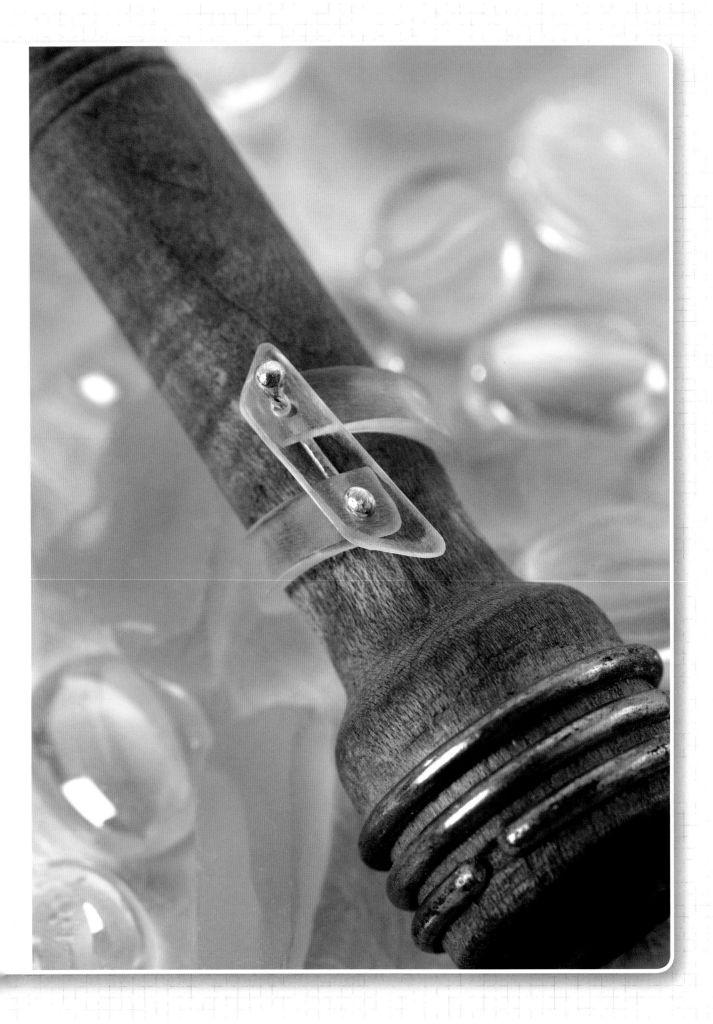

subtle distraction ring

This ring is understated but chock full of personality. Sanding the band makes Plexiglas rings extremely comfortable to wear, but if you're like me, you'll find yourself taking this ring off simply to fondle it. There's something very calming about the translucent, smooth, not-cool-to-the-touch quality of Plexiglas that makes it irresistible.

materials

4" × ¼" (10cm × 6mm) piece of Plexiglas

¼" × 1" (6mm × 3cm) piece of Plexiglas

a ring that fits you

silicone craft sheet

silver solder and flux

3" (8cm) 18-gauge wire

ring mandrel

heat gun

fine-grit sandpaper

soldering iron

Dremel tool (optional)

ruler

marker

hot knife

hand drill

¹/₁₆" (2mm) drill bit

needle-nose pliers

wire cutters

variation

« *A single bead can be a star if you prefer a touch of color.*

1» Sand and heat plastic

Slide a ring that fits you onto the ring mandrel to determine your ring size. Remember this number. Use a fine-grit sandpaper to sand both sides of the 4" x ¼" (10cm x 6mm) piece of Plexiglas. Use either a Dremel tool or sandpaper to sand the edges smooth. Lay the piece on a silicone craft sheet and heat it with a heat gun for several minutes, moving the gun around so as not to concentrate too much heat in one spot.

2» Shape ring

Form the ring around the mark for your ring size on the ring mandrel. You may need to reheat and rework the ring as necessary until it is fully shaped. Be careful handling the plastic—it will be hot.

3» Mark cut lines on ring

Slip the ring on your finger, and use a marker to mark where you would like to trim the ends off the ring, forming a design in which the ends of the ring overlap slightly.

4» Cut away excess plastic

Use a hot knife to cut along your marks and snap the ends off. Use a Dremel tool or sandpaper to sand the outside corners of the freshly cut edges.

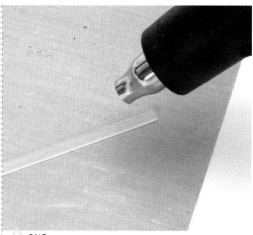

ONE

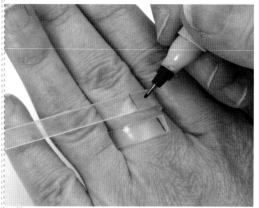

TWO

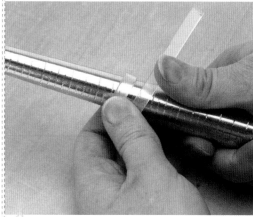

THREE

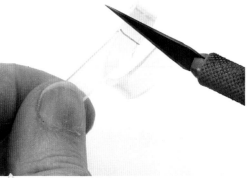

FOUR

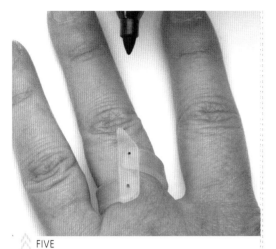

FIVE

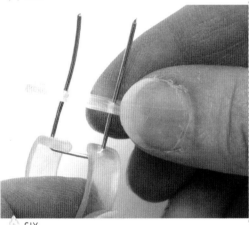

SIX

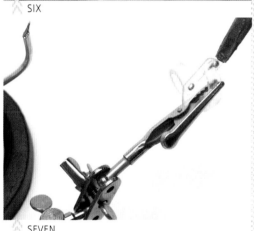

SEVEN

5›› Sand and mark embellishment piece

Use a fine-grit sandpaper to sand both sides of the ¼" x 1" (6mm x 3cm) piece of Plexiglas. Use either a Dremel tool or sandpaper to sand the edges and corners until they're smooth and the piece is formed into an imperfect oblong shape. Lay this piece across the top of your ring where the pieces overlap. Use a marker to mark where you'd like to drill two holes to attach this piece to each end of the ring. Use a hand drill and a $\frac{1}{16}$" (2mm) bit to drill through the marks. Lay this piece back in position on top of the ring. Use a marker to mark the location of the holes on the ring itself. Drill through these marks as well.

6›› Hammer and insert wire

Measure the distance (X) between the center holes. Cut a piece of 18-gauge wire to 3" (8cm). Mark the center point of the wire and measure ½X out from the center on either side. Hammer the wire flat along the total X measurement. Use needle-nose pliers to bend the wire at a 90° angle on either side of the flattened portion, and thread the wire ends through the holes in the ring and embellishment piece. Use wire cutters to trim the excess wire almost flush with the top of the embellishment.

7›› Solder wire

Put a little bit of flux on each exposed end of the wire. Pick up some solder with the soldering iron and gently press and solder it onto each end of the wire until the ends are no longer sharp and the ring is securely assembled. Avoid pressing the soldering iron directly on the plastic (it will melt!).

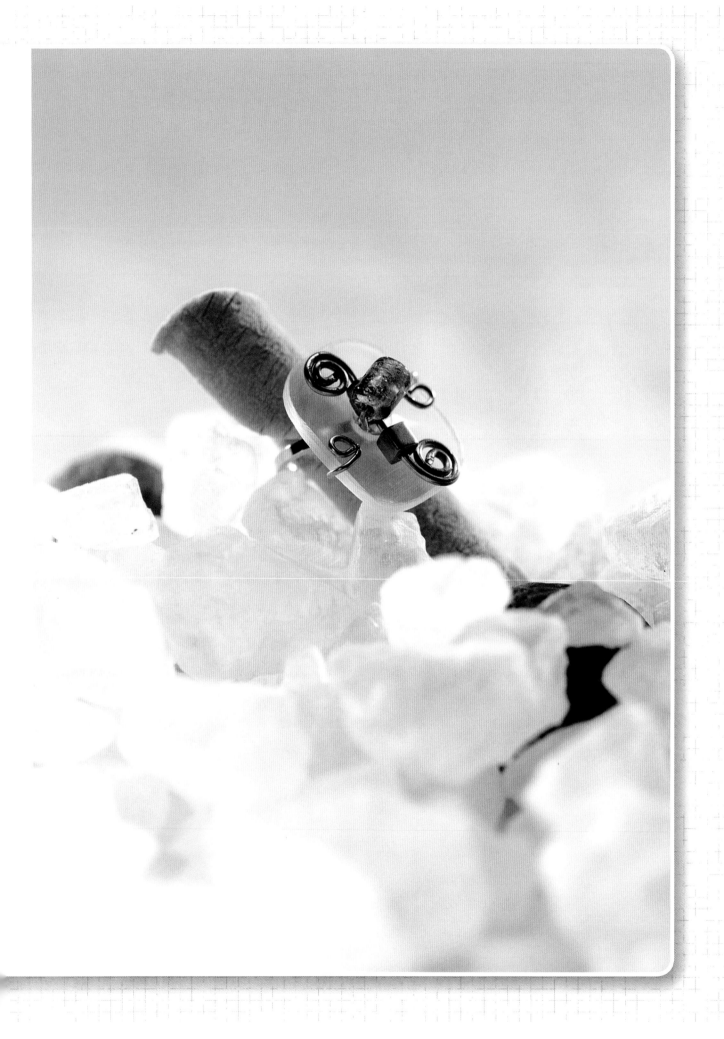

one big bead ring

There are many possibilities for this simple ring design that can showcase any beautiful, stand-alone bead. Experiment with different ways of wire wrapping, as well as different shapes for the Plexiglas. The ready-made ring base makes getting started easy—a few twists of the wire and presto!

materials

Bling Ring base (Beadalon)	3" (8cm) 20-gauge silver-colored wire	Dremel tool with sanding attachment (optional)
1" × ¾" (3cm × 2cm) piece of Plexiglas	3" (8cm) 18-gauge silver-colored wire	wire cutters
2 antique silver Japanese glass cube beads (Beadalon)	hand drill	needle-nose pliers
large blue glass bead	$^7/_{32}$" (6mm) bit	round-nose pliers
	fine-grit sandpaper	hammer

1›› Prepare main elements
Sand both sides of the Plexiglas piece with a fine-grit sandpaper. Use the sandpaper or a Dremel tool to smooth the edges and round the corners. With a $^7/_{32}$" (6mm) bit, drill a hole exactly in the center of the ring. Take the 3" (8cm) piece of 18-gauge silver-colored wire, use round-nose pliers to start a small loop at one end, then use needle-nose pliers to coil about 1" (3cm) of it into a spiral. Thread on a cube bead and push the ring-base loop through the hole in the center of the Plexiglas piece. Guide the wire through the loop, thread on another cube bead, and use both pairs of pliers to coil the other end into a spiral going in the opposite direction.

2›› Add focal bead
Thread the large blue glass bead onto the center of the 3" (8cm) length of 20-gauge silver-colored wire. Bend the wire at a 90° angle on either side of the bead. Push the ends down through the hole in the Plexiglas, positioning a wire on either side of the ring base.

3›› Twist wire ends into spirals
Bend the wire ends flush against the bottom of the Plexiglas, so they stick out from each side. Coil the ends with round-nose pliers.

4›› Finish ring
Use the needle-nose pliers to wrap the coiled wire ends tightly around the sides and down flush onto the top of the ring.

⌃ ONE

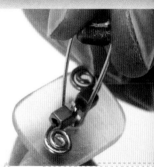
⌃ TWO

⌃ THREE

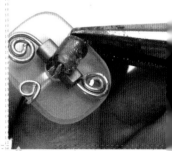
⌃ FOUR

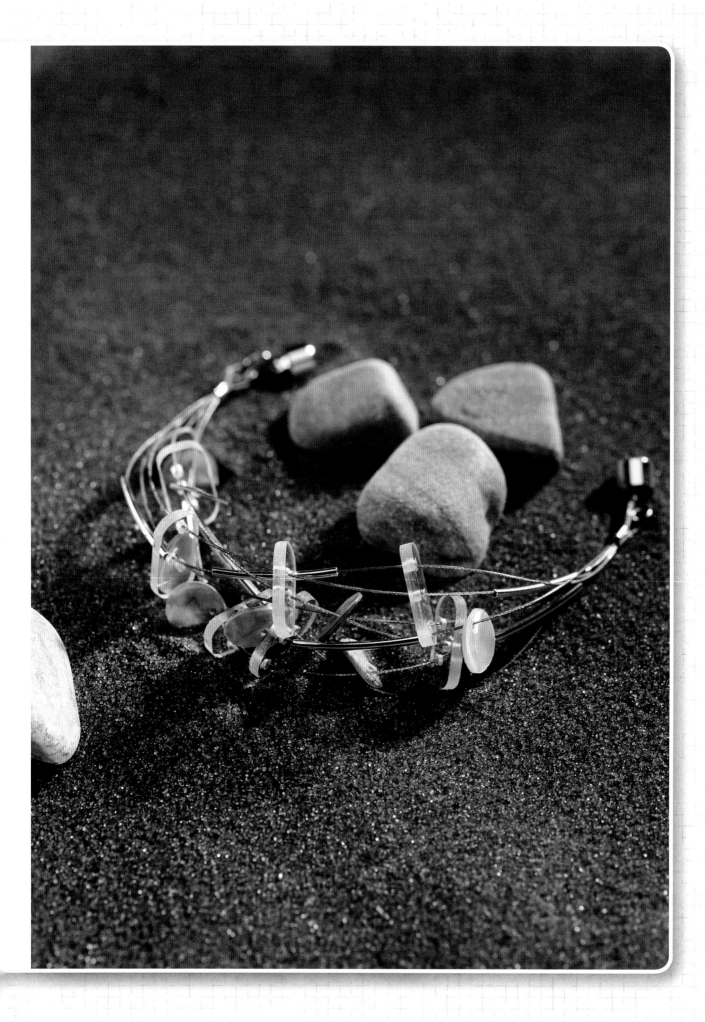

lack of concentration bracelet

Projects that provide a new challenge excite me, but sometimes a challenge requires a bit more focus than you have in you at the moment. I like this project for two reasons: It's super fast, and you don't have to think much about it. Randomly positioned holes in the Plexi pieces provide even more purely mindless fun!

materials

7 ³/₈" × ⁵/₈" (1cm × 2cm) pieces of Plexiglas

approx 5' (1.5m) .018" (.5mm) nylon-coated wire

2 4mm silver crimp tubes

7 silver spacer tube beads

10 mother-of-pearl beads

2 silver jump rings

silver magnetic clasp

crimping pliers

wire cutters

hand drill

¹/₁₆" (2mm) drill bit

fine-grit sandpaper or Dremel tool with sanding attachment

1›› **Cut and crimp wire for bracelet**
Cut 7 pieces of wire to about 8" (20cm) each. Gather the wires together and use crimping pliers to secure them all together in a crimp tube at one end.

2›› **Randomly thread components onto wires**
Using a hand drill and a ¹/₁₆" (2mm) bit, drill 3 holes in each piece of Plexiglas. Use a Dremel tool or fine-grit sandpaper to round and smooth the edges and corners. Thread a mother-of-pearl bead onto any wire. Thread the first Plexiglas bead onto the bracelet by threading any 3 wires through each of the 3 holes. Thread a silver spacer tube bead onto one of the wires you just threaded through the first Plexiglas bead, and thread a mother-of-pearl bead onto another. Choose 3 pieces of wire that were not threaded through the first bead, and thread them individually through the 3 holes in another Plexiglas bead. Continue alternating mother-of-pearl beads, spacer tube beads and Plexiglas beads onto random wires until the bracelet is full.

3›› **Crimp other end and add clasp**
Use crimping pliers to secure all of the threaded wires at the other end. Use a jump ring to attach one half of the silver magnetic clasp to each end.

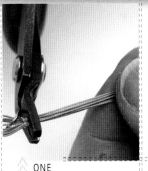
ONE

TWO

THREE

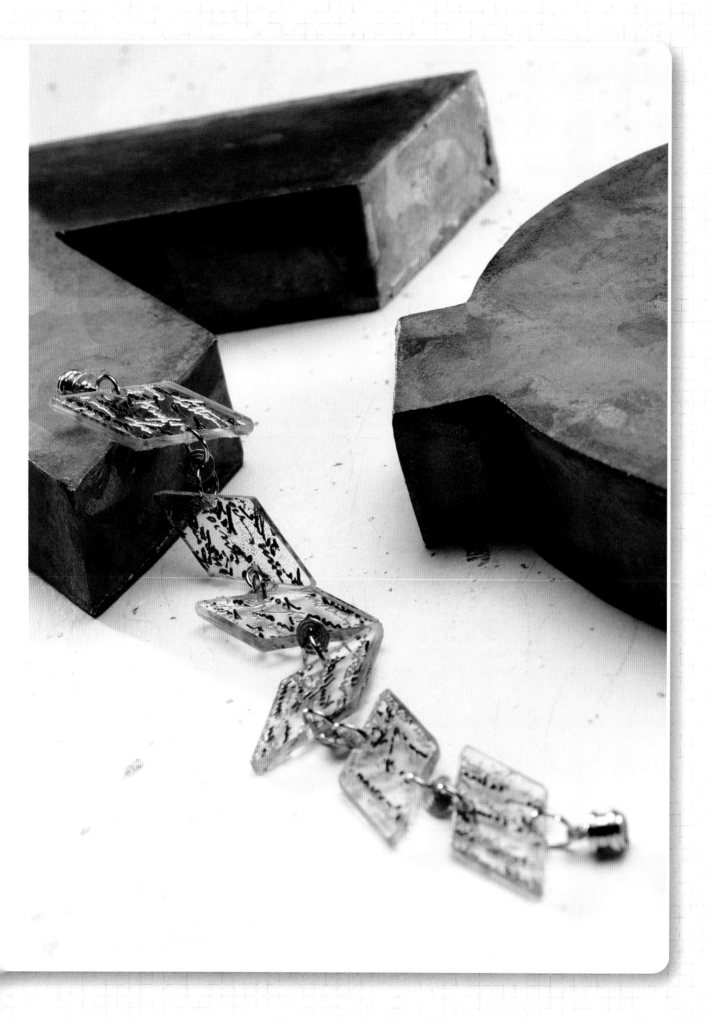

text me bracelet

Even if you don't wear your heart on your sleeve, you'll love wearing beautiful script on your wrist. Embossing powders come in many different colors and textures; the options for this look are almost endless! But keep the look clear—I recommend stamping only on unsanded plastic; otherwise, the ink of the stamped image may bleed.

materials

5/8" × 5" (2cm × 13cm) Plexiglas	silver embossing powder	hammer
5" (13cm) 22-gauge silver-colored wire	plastic cutter	metal block
magnetic clasp	clear ruler	heat gun
12 silver-colored jump rings	marker	hand drill
rubber stamp	fine-grit sandpaper or Dremel tool with sanding attachment	1/16" (2mm) drill bit
black pigment ink pad	pliers	

1 ›› Score and cut 8 charms
Use a clear ruler and a marker to draw 8 parallel lines at a diagonal, 5/8" (2cm) apart, on the Plexiglas. (The angle is not important as long as the lines are parallel.) Score along each line with a plastic cutter. Break the pieces apart. With a fine-grit sandpaper or a Dremel tool and sanding attachment, smooth the edges and corners.

2 ›› Stamp charm
Press the stamp into the black pigment ink pad and stamp the image onto the first charm.

3 ›› Sprinkle embossing powder
Sprinkle silver embossing powder over the entire stamped area. Tap the excess powder off the charm onto your work surface.

4 ›› Heat powder until it melts
Move a heat gun over the surface until the embossing powder looks shiny. Repeat steps 2–4 for both sides of each charm.

5 ›› Create spiral wire charms
Cut a length of about 1" (3cm) of 22-gauge silver-colored wire. Use round-nose pliers to twist it into a spiral. Place it on a metal block and pound it flat with a hammer. Flip it over and pound the other side flat, as well. Repeat until you have 5 flattened spiral pieces.

6 ›› Drill charms; assemble bracelet
With a 1/16" (2mm) bit, drill a hole in the center of each of the 2 parallel long sides of each charm, about 1/16" (2mm) from the edge. Assemble the bracelet in this order: embossed charm, jump ring, spiral, jump ring. Use jump rings to attach the clasp to each end.

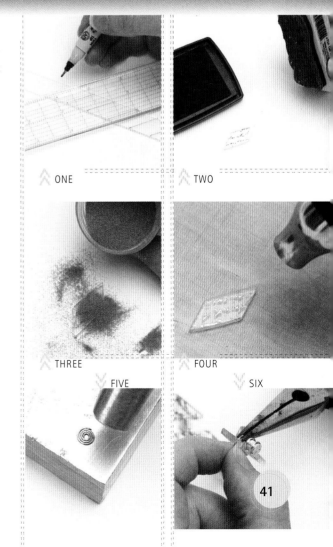

ONE

TWO

THREE

FOUR

FIVE

SIX

41

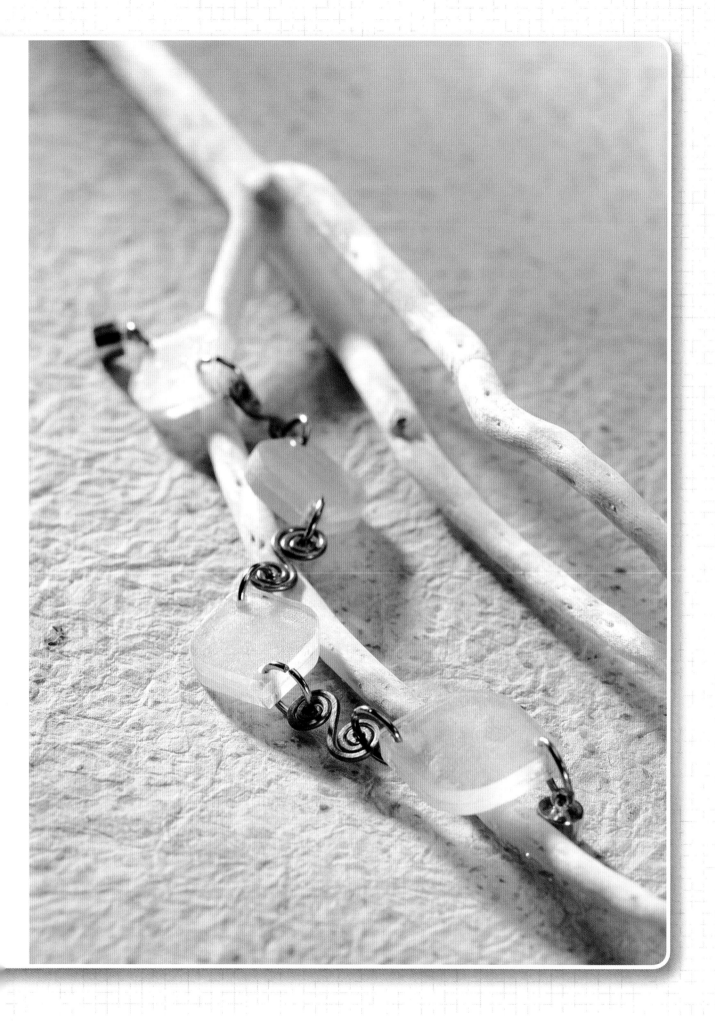

like a rock bracelet

These charms remind me of the rose quartz jewelry pieces I saw so often as a child at roadside souvenir stands during road trips with my family out West. A bit of glitter rekindles the magic of youthful adventure, and double-thickness Plexiglas gives this bracelet a nice "weight" without making it heavy.

materials

8 pieces of ¾" × ¾" (2cm × 2cm) Plexiglas	plastic cement	round-nose pliers
4 1" (3cm) square pieces of light pink tissue paper	paintbrush	wire cutters
7" (18cm) 18-gauge wire	Dremel tool with sanding attachment	hand drill
8 large silver-colored jump rings	hammer	⁵/₆₄" (2mm) drill bit
magnetic clasp	metal block	small spring clamp
	fine-grit sandpaper	glitter decoupage medium

1 ›› Adhere paper and create Plexiglas charms
Sand 1 side of 4 of the pieces of Plexiglas. With a paintbrush, apply glitter decoupage medium to the sanded side of each piece, and press each one down onto light pink tissue paper. Work out any wrinkles or air bubbles with your fingers, then apply another coat of decoupage medium. Let dry. Clamp 1 unsanded piece of Plexiglas to the paper side of each charm and brush plastic cement along the seams. (The adhesive will soak in.) Set the 4 charms aside to cure.

2 ›› Shape charms
Using a Dremel tool with the sanding attachment, heavily round 2 opposite sides of each charm, and gently round the other 2 opposite sides just until they are no longer sharp. With a ⁵/₆₄" (2mm) bit, drill 2 holes in each charm, 1 near each of the pointed ends of the charm.

3 ›› Create wire "S" charms
Cut 4 pieces of wire to 2¼" (6cm), and use round-nose pliers to coil each piece into an "S" with a spiral shape at each end, as shown. Place each "S" on the metal block, and hammer it flat.

4 ›› Assemble bracelet
Assemble the bracelet in this order: Plexiglas charm, jump ring, wire "S," jump ring. Use jump rings to attach half of the magnetic clasp to the Plexiglas charm at each end of the bracelet.

ONE

TWO

THREE

FOUR

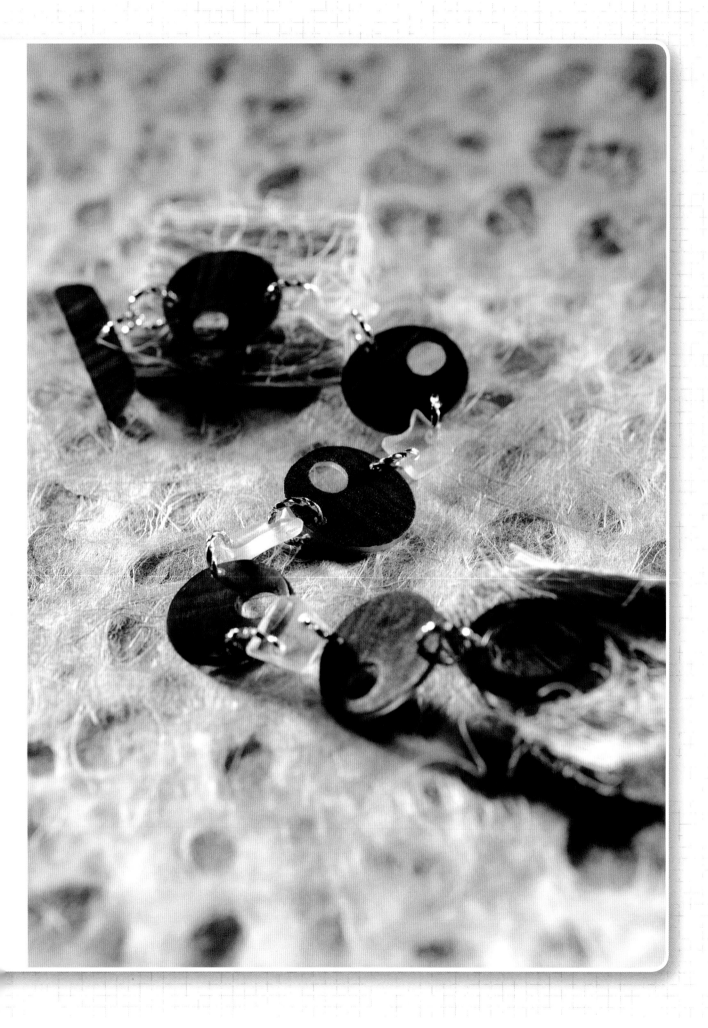

save the trees bracelet

Be prepared for many dazed and amazed looks when you tell your friends that these charms are not actually wooden. Isn't shrink plastic amazing? Think of the possibilities. You don't need to stick with circles, but I like the combination of their mod shape with the "wood" and the way they complement the irregular "glass chip" Plexiglas charms.

materials

1 sheet of frosted shrink plastic

4 pieces $3/8$" × $3/8$" (1cm × 1cm) Plexiglas

11 silver Twist jump rings (Beadalon)

$17/8$" (5cm) diameter circle template

$11/4$" (3cm) diameter circle template

light wood-colored marker

pencil

scissors

hand drill

$1/16$" (2mm) drill bit

$1/2$" (1cm) diameter circle punch

oven or toaster oven

pliers

fine-grit sandpaper or Dremel tool with sanding attachment

1 ›› Draw faux wood grain

Using a light wood-colored marker, make parallel strokes across a sheet of frosted shrink plastic, slightly overlapping each stroke.

2 ›› Trace and cut out circles

Using a 1⅞" (5cm) diameter circle template, use a pencil to trace 6 circles on the colored shrink plastic and cut them out with scissors.

3 ›› Punch an off-center hole in 5 circles

Use a ½" (1cm) diameter circle punch to punch a hole slightly off center in 1 of the cut-out circles. Lay this circle flush over another, use a pencil to trace the punched-out circle, and then use the punch to punch along your pencil lines. Repeat until 4 more circles are punched identically.

4 ›› Create open half of toggle clasp

Use a circle template and a pencil to draw a 1¼" (3cm) diameter circle in the center of the sixth circle from step 2. Use the circle punch to punch a hole in the middle, and then insert your scissors in the hole and cut along your pencil line. This will serve as one end of the toggle clasp of your bracelet.

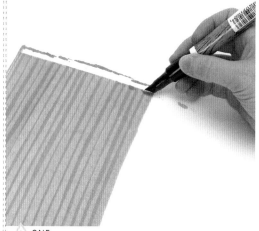

ONE

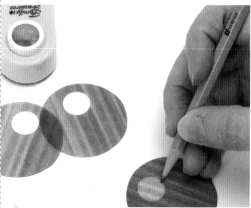

TWO

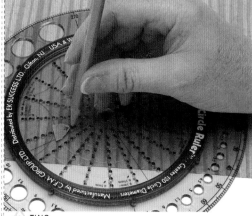

THREE

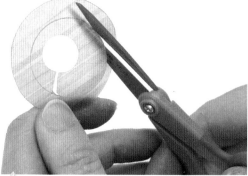

FOUR

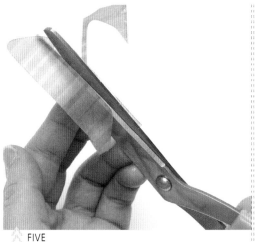

FIVE

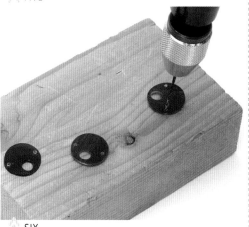

SIX

SEVEN

EIGHT

5›› Create toggle and bake shrink plastic

Use a pencil to draw a rectangle that's ⅝" × 2⅝" (2cm × 7cm) on the shrink plastic, with the short ends angling in toward one side. This will serve as the toggle of the clasp. Bake the charms and both pieces of the toggle clasp according to the manufacturer's directions. The color will darken upon shrinking.

6›› Drill holes in charms and clasp pieces

Using a hand drill and a ¹⁄₁₆" (2mm) bit, drill 2 holes across from each other to the right and the left of the punched hole in each charm. Drill a hole in the center of the toggle and a hole anywhere on the circle part of the clasp.

7›› Create Plexiglas spacer pieces

Cut 4 small squares of Plexiglas, about ⅜" × ⅜" (1cm × 1cm). Use a Dremel tool or sandpaper to smooth and shape the edges, creating irregular shapes. Use a fine-grit sandpaper to distress both sides of each piece.

8›› Use jump rings to assemble bracelet

Now you're ready to assemble the bracelet, with one section of the clasp at each end and the faux-wood charms and Plexiglas spacer pieces alternating in between, making sure to also alternate the direction of the off-center circle in each faux-wood charm. Use pliers to insert and close jump rings between each piece until they all are connected.

Plexi Pointers

›› Not into baking? Try shrinking your shrink plastic with a heat gun. A bit more care must be taken to avoid overheating the plastic, but it sure speeds things up. If the piece becomes a bit warped in the process, simply use a piece of glass or a small steel block to flatten the shrunken plastic while it's still warm.

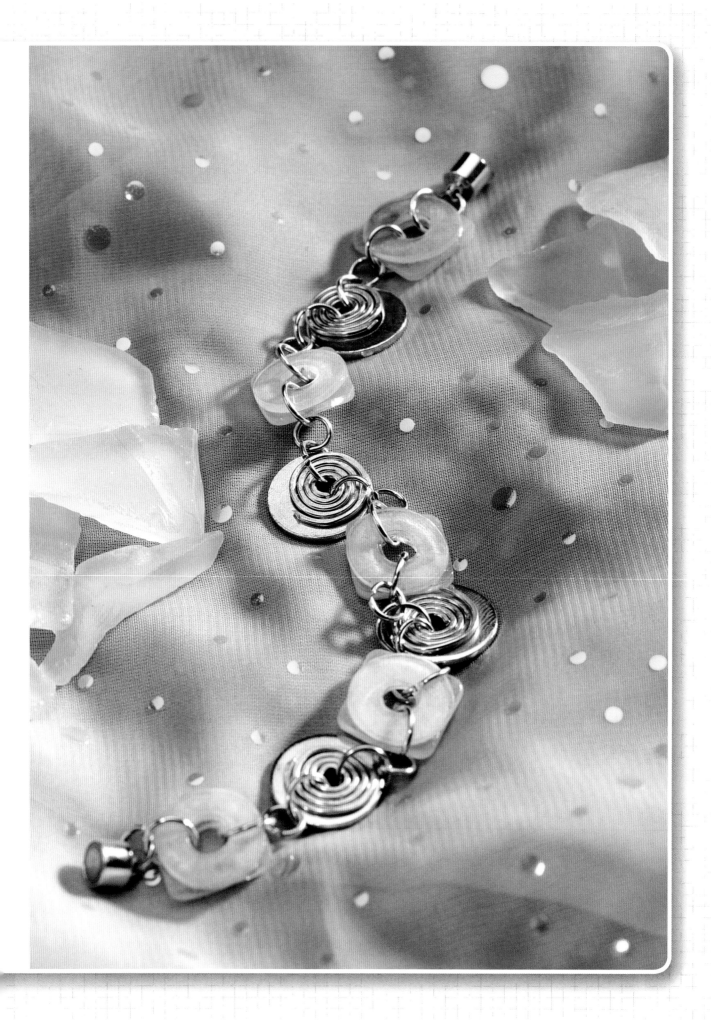

shrink 'n swirls bracelet

The charms in this bracelet remind me of fused glass, but they're sure a lot easier to make! You can create these using either clear or frosted shrink plastic and, of course, any color of tissue paper you choose. If the swirls make you dizzy, just stack a smaller-sized washer on top of the larger one to create an alternate component, and your wrist will be dressed in no time.

materials

1 sheet of frosted shrink plastic	conventional oven or toaster oven
tissue paper in 2 coordinating colors	wire cutters
matte medium	hammer
approx 46" (117cm) 18-gauge silver-colored wire	metal block
$4^{5}/_{8}$" (12cm) diameter washers	round-nose pliers
magnetic clasp	nylon-jaw pliers
1½" (4cm) diameter circle template	size US 10 (6mm) metal knitting needle
½" (1cm) diameter circle punch	size US 7 (4.5mm) metal knitting needle
corner rounder	small spring clamp
pencil	plastic cement
ruler	fine-grit sandpaper
scissors	

1›› Create shrink plastic charms

Use a ruler and a pencil to draw 5 squares measuring 1½" (4cm) and 5 circles with a 1½" (4cm) diameter onto a sheet of shrink plastic. (Use a template to draw the circles.) Cut out the shapes. Use a corner rounder to round the corners of the squares. Punch a ½" (1cm) diameter circle into the center of each circle and each square. Bake the shapes according to the manufacturer's instructions.

2›› Adhere paper to circular charms

Brush matte medium onto the back of 1 of the circular charms, and press a piece of tissue paper that is slightly larger than the charm onto the frosted side. Repeat for the other 4 circles, alternating colors of paper. Let them dry. Sand the edges until any excess paper has flaked away. Using plastic cement and securing the 2 pieces together with a clamp, adhere each circle charm, paper-side down, onto a square charm.

3›› Create spiral wire pieces

Use wire cutters to cut 4 4½" (11cm) pieces of wire. Clasping the end of 1 piece of wire in the middle of the round-nose pliers, twist the wire around the pliers once to form the small circle that will be the center of your spiral. Clasp the wire circle in a pair of nylon-jaw pliers and twist the remainder of the wire into a spiral.

ONE

TWO

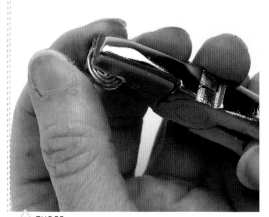

THREE

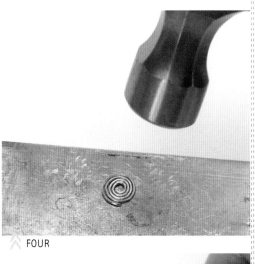

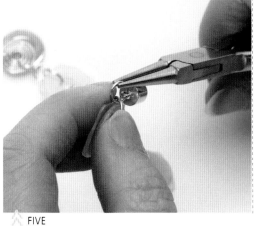

FOUR

4›› Flatten spirals
Lay each spiral on a metal block and pound it with a hammer. Flip each spiral over to the other side and hammer it again until it is flattened.

5›› Create jump rings and assemble bracelet
Wrap the wire around the size US 10 (6mm) knitting needle until you've created a coil of about 20 complete loops. Use wire cutters to cut this coil into 18 jump rings. Then, wrap the wire around the size US 7 (4.5mm) knitting needle until you've created a coil of about 12 complete loops. Use the wire cutters to cut this coil into 10 jump rings. Use round-nose pliers to assemble the bracelet in this order: magnetic clasp, small jump ring, big jump ring, charm of Color A, big jump ring, small jump ring, big jump ring, spiral stacked on top of washer, big jump ring, small jump ring, charm of Color B, etc.

FIVE

Plexi Pointers

>> Sections made from a single layer of shrink plastic can look just as great as the double-layered ones used in this project. Try cutting out individual square and circle shapes, then alternating them with the washer sections for a different look.

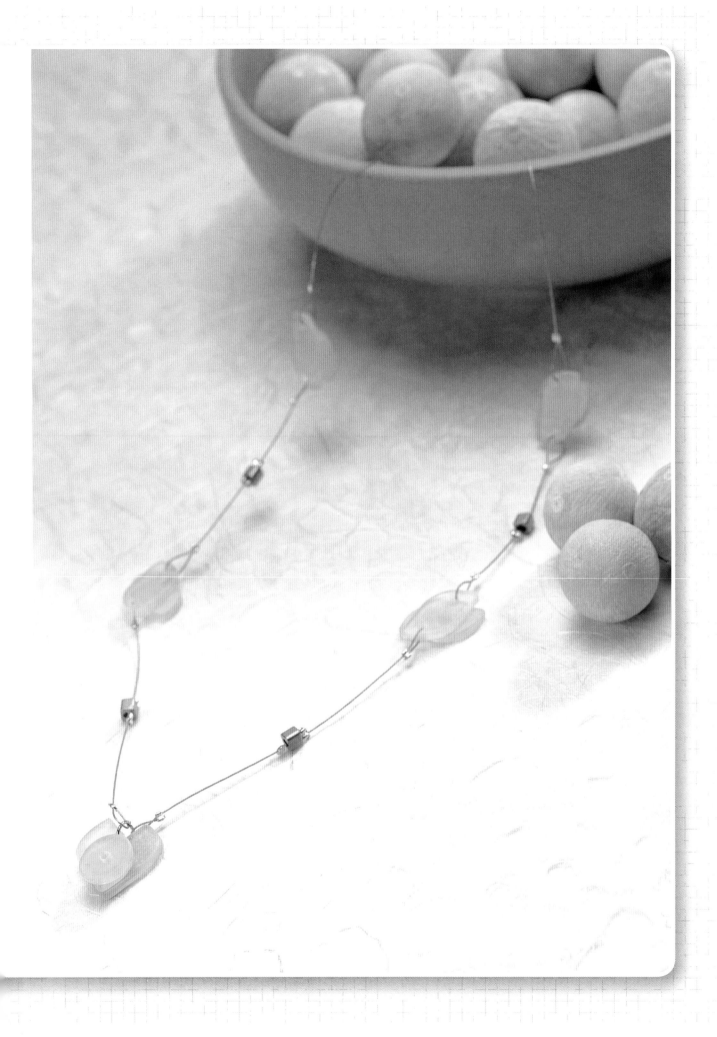

wispy leaves necklace

The beauty of this necklace is in its visual weightlessness—like wind rustling through the trees. Coated wire is fun to use and makes minimalism easy. This concept would work equally well with geometric forms, perhaps circles or squares, with a simple heart as the focal point.

materials

10 pieces of $^3/_8$" × $^3/_4$" (1cm × 2cm) Plexiglas

$^1/_2$" (1cm) square piece of Plexiglas

light blue tissue paper

lime green tissue paper

1 yd (1m) 0.18" nylon-coated wire

12 #1 crimp beads

8 #2 crimp beads

4 antique silver Japanese glass cube beads (Beadalon)

2 jump rings

magnetic clasp

fine-grit sandpaper

Dremel tool with sanding attachment (optional but recommended)

hand drill

$^3/_{32}$" (2mm) drill bit

crimping pliers

wire cutters

scissors

small spring clamp

tabletop vise

matte medium

plastic cement

1» Sand Plexigas pieces into leaf shapes

Using a Dremel tool with the sanding attachment or a piece of sandpaper, sand the opposite corners of each piece of Plexiglas until it is curved into a leaf shape. Use a fine-grit sandpaper to sand both sides of 5 of the leaves. Lay the other 5 leaves so that 3 of them face one direction and 2 face the other, then sand the topside of each leaf. Finally, sand the edges of the ½" (1cm) piece of Plexiglas to shape it into a circle, and then sand both sides of its surface.

2» Adhere paper to leaves

Cut 5 pieces of blue tissue paper and 5 pieces of green tissue paper to a size slightly bigger than the leaves. Brush matte medium onto 1 side of each leaf that has been sanded on both sides. Press each one onto a piece of blue tissue paper, smooth out any wrinkles or air bubbles and apply another coat of matte medium. Repeat to adhere green tissue paper to the sanded side of the other 5 leaves and to the circle. Let them dry.

Clamp a blue leaf, paper-side down, on top of a green leaf, paper-side down, with the tips nearly touching, as shown. Glue the circular piece paper-side down where the 2 intersect. Pair each of the remaining blue leaves with a green leaf facing the opposite direction, and use plastic cement to adhere each pair together.

3» Drill holes

Secure each of the 4 pairs of leaves in a tabletop vise and use a hand drill and a ³/₃₂" (2mm) bit to drill a hole in each tip of each blue leaf. Secure the heart-shaped piece in the vise and drill a hole in the center of the circle down through all 3 layers, and another hole just above the circle through both layers of leaves.

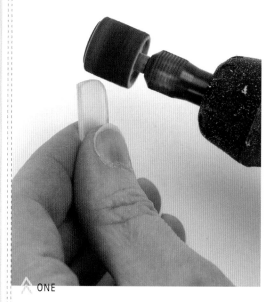

ONE

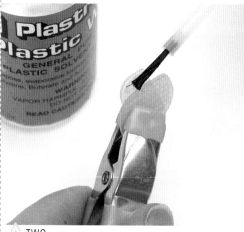

TWO

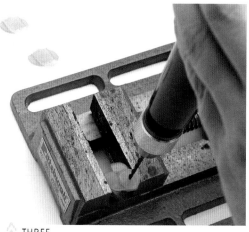

THREE

Plexi Pointers

>> As an alternative to the coated wire and crimp beads, you could use beading cord and tie knots between the Plexiglas pieces and the other beads.

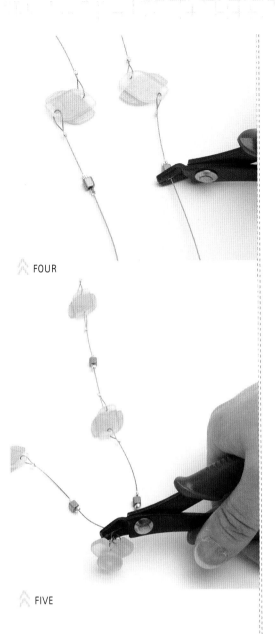

FIVE

4›› Begin constructing necklace

Begin constructing the necklace from the sides inward. First, cut 2 pieces of nylon-coated wire to 4½" (11cm). Form a small loop at the end of each wire and use crimping pliers and a #1 crimp bead to secure it. Thread the other end of each loop through 1 end of a leaf charm, and use a #1 crimp bead to close each loop. Next, cut 2 pieces of the wire to 4" (10cm), loop each one through the other end of each leaf charm, and secure with a #1 crimp bead. Thread a cube bead about halfway up each length of wire, and crimp a #2 crimp onto either side of it to keep it in place. Repeat this process to add 1 more leaf and 1 more cube bead to each side.

5›› Connect center piece

Attach a jump ring through the upper loop in the remaining piece. Loop the 2 wire ends through the jump ring, and crimp each loop closed with a #1 crimp bead. Finish by using a jump ring to attach half of the magnetic clasp to each end.

Plexi Pointers

›› Instead of adhering paper to half of the Plexiglas pieces, try using alcohol inks to tint the plastic the color of your choice.

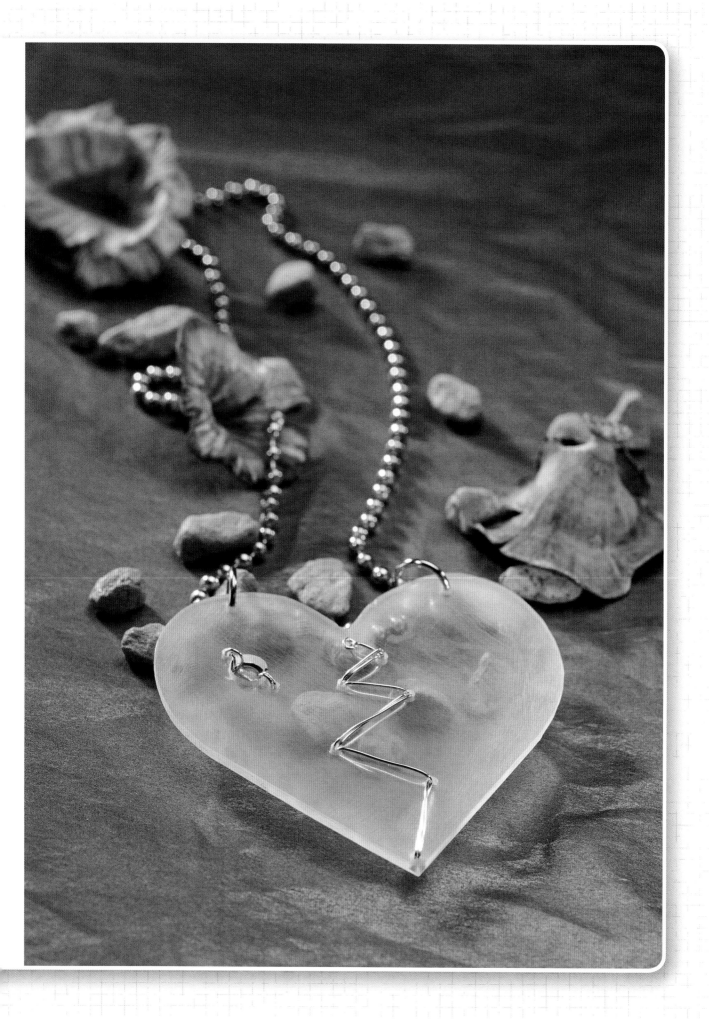

heart on a string choker

This choker lets you wear your heart not on your sleeve, but around your neck—front and center. I find carving shapes from Plexiglas to be secretly satisfying, because while the results are impressive, the method is far simpler than it looks. Try making one of your initials, a star or a giant flower for equally dramatic results.

$2^3/_8$" × $2^3/_8$" (6cm × 6cm) piece of Plexiglas

pink glass bead

approx 16" (41cm) 22-gauge silver-colored wire

2 large jump rings

16" (41cm) ball chain

fine-grit sandpaper

hot knife (preferred) or plastic cutter

straightedge

hand drill

5 drill bits: $^1/_{16}$" (2mm), $^5/_{16}$" (8mm) and 3 sizes in between

pliers

wire cutters

Dremel tool with sanding attachment

scrap paper

marker

circular template

1 ›› Trace heart onto Plexiglas

Sand both sides of the Plexiglas square. Cut a heart shape out of scrap paper to use as a template, and use a marker to trace it onto the plastic.

2 ›› Cut away excess plastic

Using either a straightedge and a hot knife or a plastic cutter, cut away as much excess plastic outside of the heart shape as you can.

3 ›› Sand heart to shape

With the Dremel tool and a sanding attachment, sand all of the edges to form a smooth, more perfect heart shape.

4 ›› Precision cut inside point

Use a hot knife or plastic cutter to cut the last little bit of plastic away from the inside point at the top of the heart.

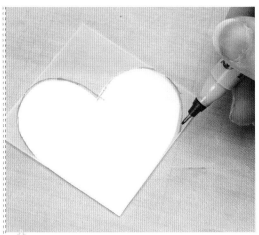

ONE

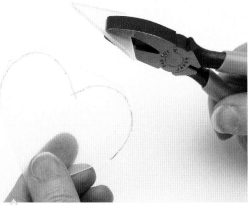

TWO

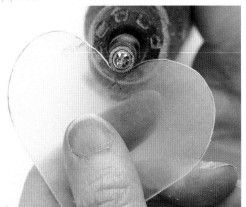

THREE

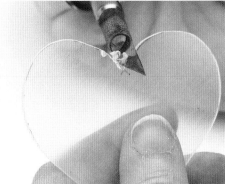

FOUR

Plexi Pointers

>> A jeweler's saw can also be used to remove small pieces of Plexiglas from a tight spot, like the top center of the heart shown here.

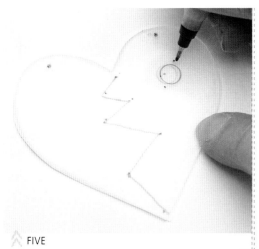

FIVE

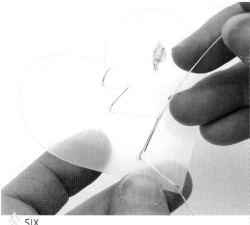

SIX

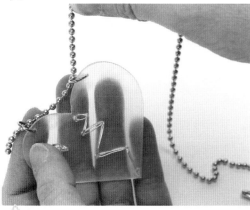

SEVEN

5›› Mark and drill design

Using the heart template used in step 1, create a zigzag design down the center of the heart. In the upper right area, trace a circular template slightly bigger than the diameter of the bead, and mark a dot to the right and left of the circle. Make another dot in the top center of each half of the heart. Lay the Plexiglas piece back on top of the heart template, and use a marker to make a dot on the Plexiglas at each point of the zigzag. Transfer the other marks onto the Plexiglas. Drill through all of the marks and through the center of the circle with a $1/16$" (2mm) bit. For the circle, gradually drill over the same spot with increasingly bigger bits until you work your way up to the $5/16$" (8mm) bit.

6›› Add bead-and-wire zigzag

Wire the bead into the biggest circle as described in steps 4–6 of the ponytail holder (see page 77). Cut another piece of wire, about 10" (25cm) long. Use your pliers to twist the end into a tight, knot-like loop to keep it from sliding through the first hole. Thread the wire from the back through the top hole in the center of the heart. Continue threading the wire in a zigzag fashion, pulling it taut through each hole, all the way down to the bottom hole, then all the way back up to the top hole, then to the bottom hole once more. Trim the end of the wire, leaving about $1/4$" (6mm), and curl the end of the wire into a little ball to secure the zigzag.

7›› Attach jump rings and slide on chain

Attach the 2 jump rings to the 2 holes at the top of the heart. Slide the ball chain through the jump rings.

Plexi Pointers

›› For a more colorful alternative to wire "stitching," try drilling holes to create a dotted line, then using embroidery floss or beading cord to sew a running stitch through them. For a cohesive look, wear the pendant on a length of coordinating cord instead of on a chain.

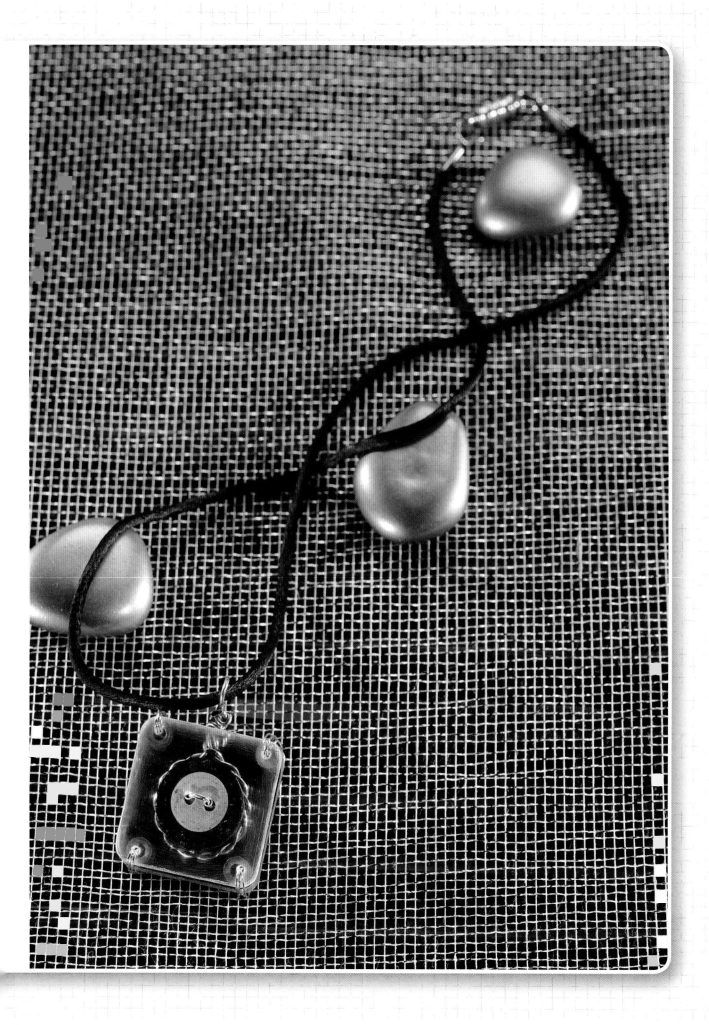

off-the-collar pendant

Simple squares of Plexiglas allow you to turn some of your most treasured ephemera into wearable showpieces, lending importance to the objects in the form of a see-through stage. Buttons are natural fodder for this project, as they come ready with holes. But don't let that stop you from using other items you'd like to display: You could either drill holes though them, or simply secure them with wire.

materials

2 1¼" (3cm) squares of Plexiglas

4 spacer beads

2 decorative buttons, one larger in diameter than the other

colored tissue paper

ribbon cut to desired length of necklace

14" (36cm) 18-gauge wire

approx 1 yd (1m) 24-gauge silver-colored wire

2 ribbon crimps

2 jump rings

magnetic clasp

hand drill and ¹/₁₆" (2mm) drill bit

fine-grit sandpaper

Dremel tool with sanding attachment (optional)

paintbrush

size US 7 (4.5mm) metal knitting needle

needle-nose pliers

wire cutters

vise

sewing needle and thread

marker

matte medium

1 ›› Prepare 2 pieces of Plexiglas

Use sandpaper or a Dremel tool with the sanding attachment to sand the edges and round the corners of both Plexiglas squares. Use a fine-grit sandpaper to frost both sides of 1 square, but leave the other piece clear. Use a marker to mark a tiny dot in each of the corners of the frosted piece of Plexiglas. Center the button beneath this piece, and mark the location of the buttonholes. Position this piece flush on top of the clear piece of Plexiglas and tape the 2 together. Use a $1/16$" (2mm) drill bit to drill through both pieces at the marks. Take the clear piece of Plexiglas and use a Dremel tool with the sandpaper attachment or a fine-grit piece of sandpaper to very carefully sand around all 4 edges only, creating the effect of a clear window in the middle.

2 ›› Add colored paper and twist wire

Brush a coat of matte medium onto 1 side of the frosted piece of Plexiglas, and press it firmly onto a piece of colored tissue paper. Smooth out any wrinkles or air bubbles with your fingers, apply another coat of matte medium, and let it dry. Sand the edges clean of any excess paper.

Double a piece of 18-gauge silver-colored wire approx 14" (36cm) long around a size US 7 (4.5mm) metal knitting needle. Clamp the 2 ends in a vise and twist the knitting needle repeatedly to create a tightly twisted length of wire. Release the twisted wire from the vise.

3 ›› Create wire enclosure for buttons

Use needle-nose pliers to bend the twisted wire at a right angle approximately ¼" (6mm) from the base of the loop. From this point, wrap the wire around a dowel approximately the same diameter as the largest button. Once you've formed a circle, wrap the remaining wire twice around the straight length of wire at the top and trim with wire cutters.

4 ›› Align and bind pendant components

Loosely assemble the pendant, first placing the bottom piece of Plexiglas paper-side up, then stacking the remaining components in the following order: wire loop, larger button, smaller button, remaining Plexiglas square. Pass a needle and thread through the center holes and tie a knot to lightly hold the components in position.

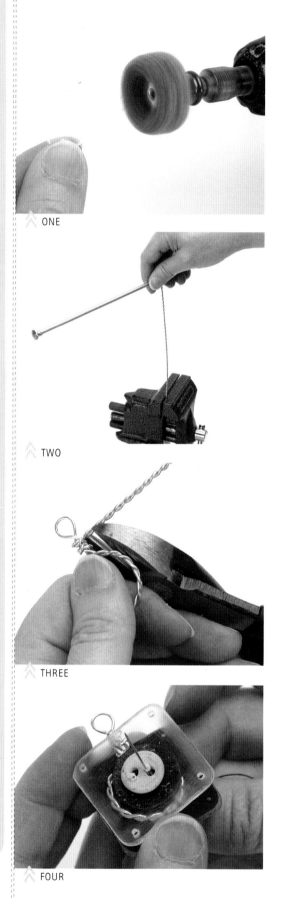

⌃ ONE

⌃ TWO

⌃ THREE

⌃ FOUR

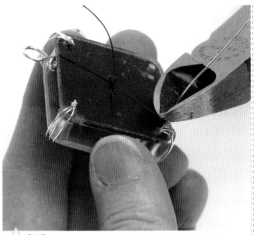

FIVE

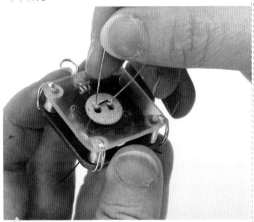

SIX

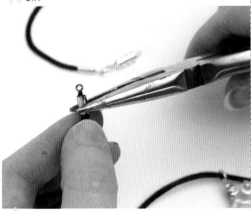

SEVEN

5›› Add spacers and wire corners together

Cut four pieces of 24-gauge silver-colored wire to approximately 7" (18cm) each. Thread the wire through the bottom Plexiglas piece of one corner, then through a spacer bead, and then through the top piece of that corner. Leave about 1" (3cm) of wire at the top, then bend it down to the side to hold it in place. Wrap the long end of the wire tightly around the side and down through the pendant. Wrap it about 3 times until the corner is securely fastened, then twist the wire ends together on the bottom of the pendant, trim the excess wire with wire cutters and use pliers to push any sharp ends flush against the bottom of the pendant. Repeat for all 4 corners.

6›› Thread wire through center holes

Remove the thread you placed through the center holes in step 4. Then using the technique described in step 5, thread another 7" (18cm) length of 24-gauge silver-colored wire through the center holes twice, then twist the ends together behind the pendant, trim the excess wire with wire cutters and use pliers to push any sharp ends flush against the plastic.

7›› Add ribbon crimps to ends of cord

Thread a length of cord or ribbon (I used a 20" [51cm] silk cord) through the top loop of the pendant, then add a ribbon crimp to each end. Use a jump ring to attach a magnetic clasp to each crimp.

Plexi Pointers

>> If sewing the Plexiglas pieces together in the corners is too much wire for your taste, use micro nuts and bolts to assemble the pendant instead.

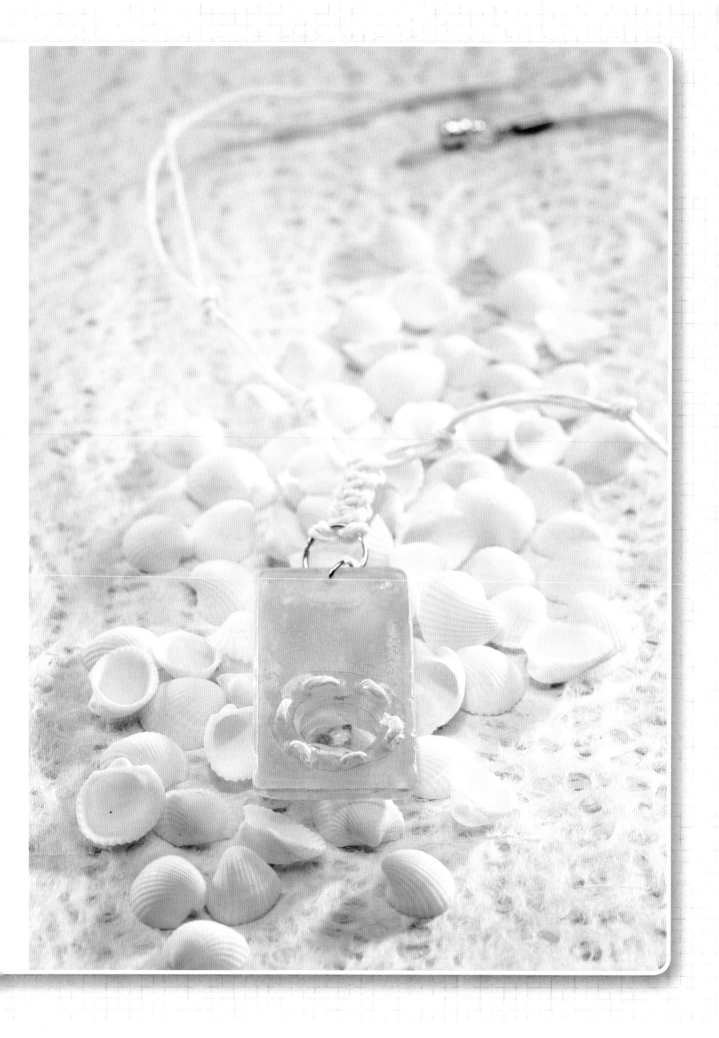

knotted nautical necklace

Showcasing tiny treasures from the sea, this nautical necklace reflects the colors of the water I long to live closer to. Vinyl is great to work with. Not only can you see through it, but it's pliable and will stretch slightly, making it a forgiving material when you are trying to sew it down just right. Here it encases my baby sand dollar like a glassy tidal pool.

materials

2 1" x 2" (3cm x 5cm) Plexiglas rectangles

light blue tissue paper, slightly larger than Plexiglas pieces

baby sand dollar (or any other piece thinner than the width of 2 pieces of Plexiglas)

small seashell

approx 1" (3cm) 18-gauge silver-colored wire

ribbon clasp

piece of vinyl, approx 1" x 2" (3cm x 5cm)

4 yds (3.5m) hemp cord

assorted circular templates

marker

piece of scrap paper

fine-grit sandpaper

Dremel tool with sanding attachment (optional)

scissors

paintbrush

hand drill

6 drill bits: $5/64$" (2mm), $3/8$" (1cm) and about 4 sizes in between

$1/16$" (2mm) hole punch

½" (1cm) knitting needle

1 small jump ring

small clamp

matte medium

epoxy

plastic cement

wire cutters

1» Create Plexiglas sandwich

Use fine-grit sandpaper to sand both surfaces of both pieces of Plexiglas until they appear frosted. Brush a coat of matte medium onto one side of both pieces, and press them firmly onto a piece of light blue tissue paper. Use your fingers to smooth out any wrinkles or air bubbles, and let the matte medium dry. Sand the edges clean of any excess paper. Clamp the 2 pieces together with the paper sides on the inside and use plastic cement to adhere them together. Let dry.

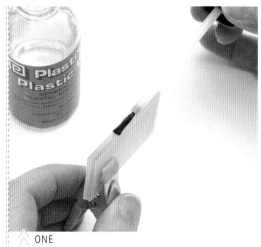

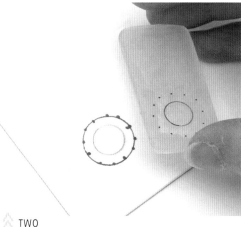

ONE

2» Mark for circle and hole placement

Use sandpaper or a Dremel tool with the sanding attachment to slightly round the corners of the pendant and to smooth all of the edges. Measure the diameter of the baby sand dollar, then use a circular template and a marker to draw a slightly bigger circle (to accommodate the sand dollar) on a piece of scrap paper, creating a template for your necklace. Center this circle inside a circular template 1/8" (3mm) larger than the first circle and trace it. Then, mark 12 evenly spaced dots around the outer circle, like the 12 hours marked on a clock. Center the bottom half of your pendant horizontally over this template. Use a marker to trace the inner circle and the outer dots onto the Plexiglas.

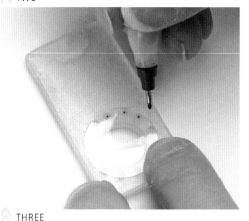

TWO

3» Drill holes and cut and mark vinyl

With a 5/64" (2mm) bit, drill a hole at the top center of the pendant near the edge and drill holes through all 12 dots. Then, in the center of the inner circle, begin by drilling a hole with the 5/64" (2mm) bit, then increase the bit size and continue drilling through the same hole until you can work the 3/8" (1cm) drill bit (or whatever matches the diameter of your inner circle) through the Plexiglas. Use a 7/8" (2cm) diameter circular template and a marker to trace 2 circles on the vinyl, and cut them out with scissors. Center 1 vinyl circle on top of the circle of 12 drilled holes, and mark the location of each hole with a dot as shown.

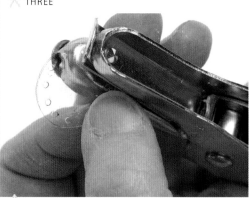

THREE

4» Punch vinyl circles

Lay this vinyl circle flush on top of the other. With the 1/16" (2mm) hole punch, punch through each mark, penetrating both layers of vinyl.

FOUR

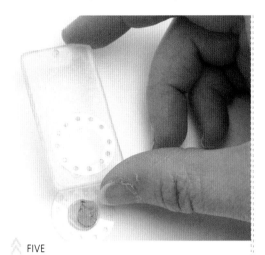

FIVE

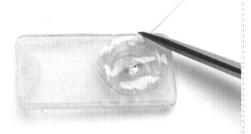

SIX

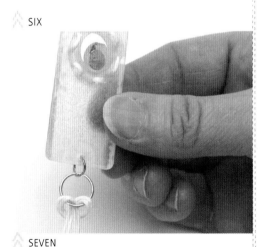

SEVEN

5›› Align elements with pendant

Lay one circle of vinyl on your work surface, positioning it so the holes align with those drilled in the pendant. Lay the seashell in the center of the vinyl and the baby sand dollar inside of the seashell. Position the pendant over all the elements, and align the holes of the remaining vinyl circle on top.

6›› Sew vinyl together

Cut a length of hemp cord to approximately 12" (30cm), and carefully hold all the elements in place as you thread the cord through the holes in the vinyl and the pendant, sewing everything together with a straight stitch. Tie the ends together in the back of the pendant, and brush a bit of epoxy over the joint to reinforce it. Let it dry, then trim the ends away.

7›› Create jump rings and cord

Wrap a piece of 18-gauge silver-colored wire around a ½" (1cm) knitting needle once, and clip the resulting loop to create a jump ring. Attach a smaller store-bought jump ring to the hole at the top of the pendant, as well as to the jump ring you just made. Cut 2 5' (1.5m) pieces of hemp cord. Fold each piece in half. Push the folded loops through the bigger jump ring and pull each set of 2 ends through each of the folded loops.

Tie various decorative knots along the cord as desired. I tied 7 macramé knots just above the large jump ring, then 2 additional knots on each side of the cord. Cut the cord to your desired length, then use pliers to attach a ribbon clasp to each end.

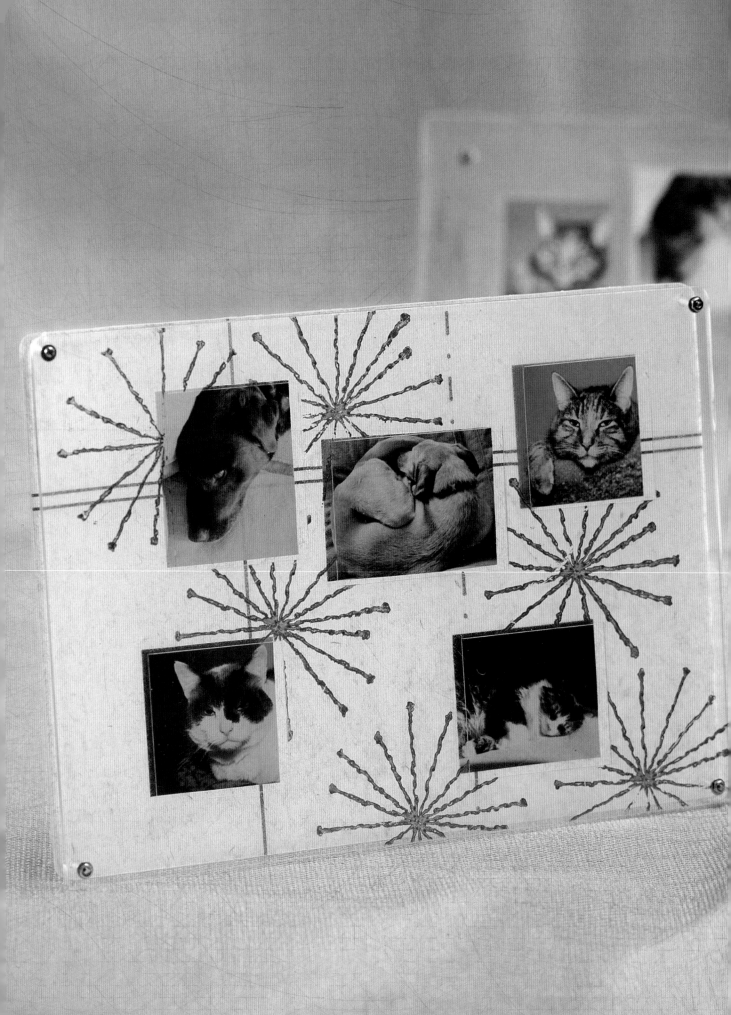

Plexi Accessories

Now that you have discovered the many ways

in which Plexiglas can be transformed from a paper-backed sheet into spectacular pieces of jewelry, I want to show you what else you can do with this versatile medium to get your plastic fix. The techniques employed in this section are the same ones used in the jewelry projects, but for the most part, the scale is simply a bit bigger.

Belts, barrettes, boxes and bags can all be made from Plexiglas. Its durability makes it a great choice for things like coasters, a checkbook cover and a tote bag. And its unique aesthetic makes it a dramatic and unexpected element in items like a purse or a dog collar. Of course, no respectable book on Plexiglas would be complete without a framing project or two—and it's so light, the resulting frame is suitable for decorating even the flimsy foam walls of a cubicle.

No doubt, by the time you're finished with this book, you will discover even more ways to create accessories with Plexiglas. When you do, I hope you will share your excitement with others and encourage them to join the Plexi Party!

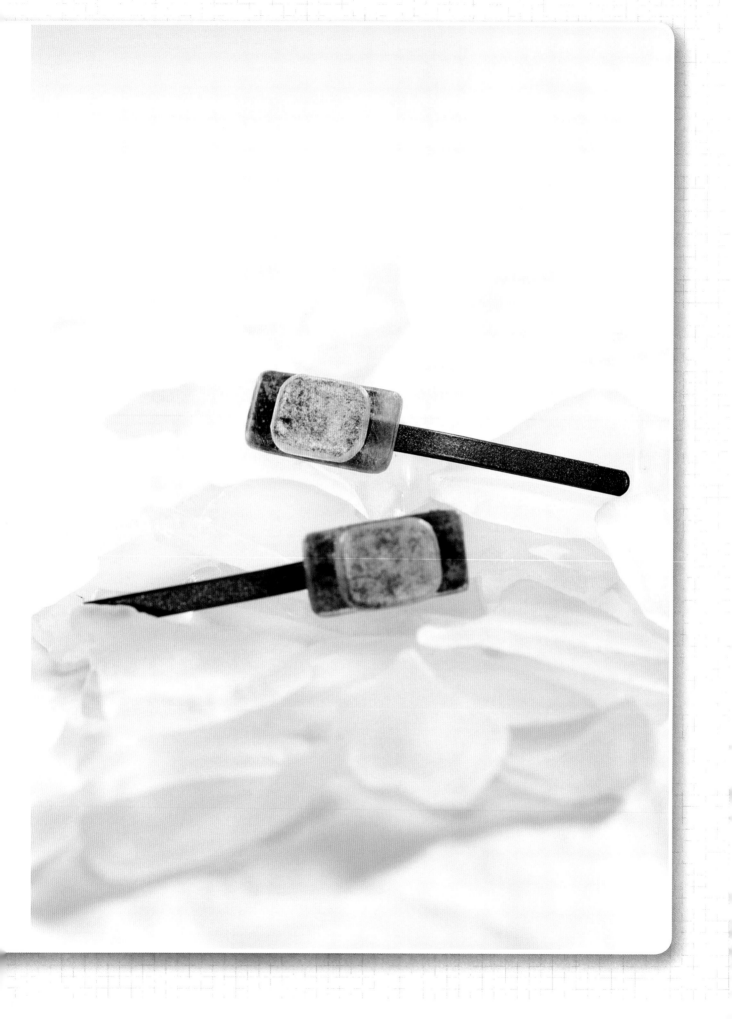

sweet and simple hairpins

These hairpins look especially good when multiples are worn together, and they are so quick to complete that making several at one time is not a problem. Tissue paper can be found in just about any color to suit your wardrobe, or for a look that's more futuristic, stick with clear Plexiglas and wear them with virtually anything.

materials

2 ½" × 1" (1cm × 3cm) pieces of Plexiglas	paintbrush
2 ½" × ⅝" (1cm × 1cm) pieces of Plexiglas	small clamp
tissue paper in 2 colors	matte medium
2 dark brown bobby pins	plastic cement
fine-grit sandpaper	epoxy
Dremel tool with sanding attachment (optional)	

1» Prepare Plexiglas components
Use fine-grit sandpaper to sand 1 surface of each Plexiglas piece. Use the sandpaper or a Dremel tool to round all the corners and smooth all the edges. With a paintbrush, apply matte medium to the sanded side of each piece. Press the large pieces firmly down onto the darker color of tissue paper and the small pieces firmly down onto the lighter color of tissue paper. Use your fingers to smooth out any wrinkles or bubbles in the paper, then finish by brushing on another coat of matte medium. Let all the pieces dry, then sand the edges to eliminate any excess paper.

2» Adhere layers of Plexiglas
Clamp the 2 pieces together and use plastic cement to adhere one small piece in the center of each larger piece. Set aside to cure.

3» Adhere Plexiglas to bobby pin
Brush a little bit of epoxy onto the top of each bobby pin, being careful it doesn't ooze onto the bottom part of the pin, and press the Plexiglas embellishment into place. Set aside to cure.

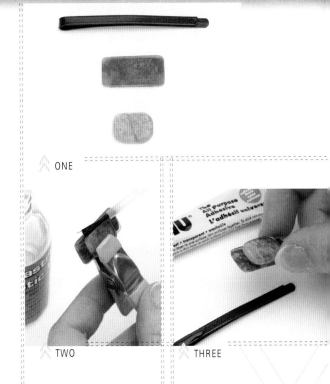

ONE

TWO

THREE

71

paper penchant barrette

We all know that the amazing array of scrapbooking papers available on the market is impossible to resist—literally. Most of us have more paper than we know what to do with! Why not turn one of your favorite patterns into a stylish hair accessory? If your scrapbook stash includes brads, you could even try substituting those for the vintage pearl buttons used here.

materials

1" × 4¼" (3cm × 11cm) piece of Plexiglas

barrette base

piece of patterned scrapbook paper

3 decorative buttons

approx 8" (20cm) 20-gauge Mint Permanently Colored Copper Wire (Beadalon)

silicone craft sheet

hand drill

1/16" (2mm) drill bit

heat gun

paintbrush

fine-grit sandpaper

Dremel tool with sanding attachment (optional)

needle or thumbtack

pliers

wire cutters

permanent marker

matte medium

epoxy

variation

≪ *Long eyelets and a page from a magazine can create eye-catching contrast.*

1›› Mark and drill pattern into Plexiglas

Use fine-grit sandpaper to sand both surfaces of the Plexiglas. Using either the sandpaper or the Dremel tool and sanding attachment, smooth the edges and slightly round the corners. Lay the piece of Plexiglas over a section of the patterned scrapbook paper you like, and use a permanent marker to doodle some dots onto the Plexiglas that follow or complement the pattern. Lay out any additional elements as well. With a hand drill and a ¹⁄₁₆" (2mm) bit, drill through all the holes.

2›› Heat and bend Plexiglas

Lay the drilled piece of Plexiglas on a silicone craft sheet, and heat the Plexiglas with a heat gun, being careful to keep the gun moving so as not to concentrate too much heat in any one spot. Once it is pliable, form the Plexiglas around the curve of the barrette base. Be careful handling the plastic—it will be hot.

3›› Adhere paper and punch holes

Brush a coat of matte medium onto the back side of the Plexiglas. Use your fingers to press the decorative paper into the position you decided upon in step 1. Smooth out any wrinkles or air bubbles with your fingers, and apply another coat of matte medium. Let dry. Use a needle or thumbtack to punch clean holes in the paper through the holes you drilled in step 1.

4›› Mark and drill holes

Place the Plexiglas piece right-side down, place the barrette base into place and make 2 tiny marks (for the buttonholes) inside the hole at each end of the barrette base. With a ¹⁄₁₆" (2mm) bit, drill through each mark.

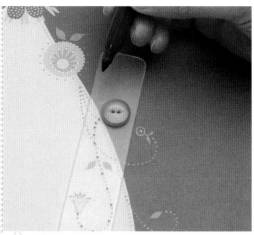

ᐱ ONE

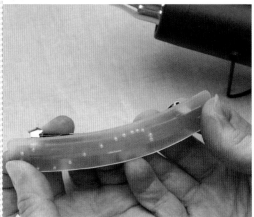

ᐱ TWO

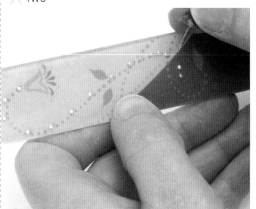

ᐱ THREE

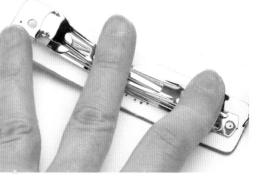

ᐱ FOUR

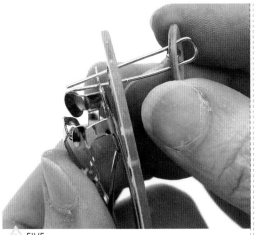

FIVE

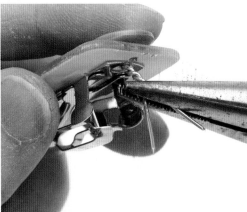

SIX

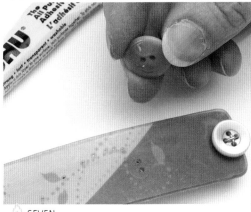

SEVEN

5›› Attach buttons and barrette to Plexiglas

Cut a 1" (3cm) piece of wire in a coordinating color, thread it through 2 of the opposite holes in the center of 1 of the buttons, and use pliers to press the ends flush against the bottom of the button to hold it in place. Place the plastic piece back in position on top of the barrette base, and position the 2 empty holes in the center of 1 button on top of the holes you drilled on the end of the Plexiglas. Cut another length of wire to approximately 3" (8cm) and use your pliers to bend it loosely in half. Thread the wire through the button, then the Plexiglas, then the barrette base.

6›› Secure barrette together

Twist the ends together several times on the bottom to secure them in place, then trim off the excess. Repeat steps 5–6 for the other side of the barrette.

7›› Add final embellishment

Use epoxy to adhere the final embellishment to the top of the barrette. Set it aside to cure.

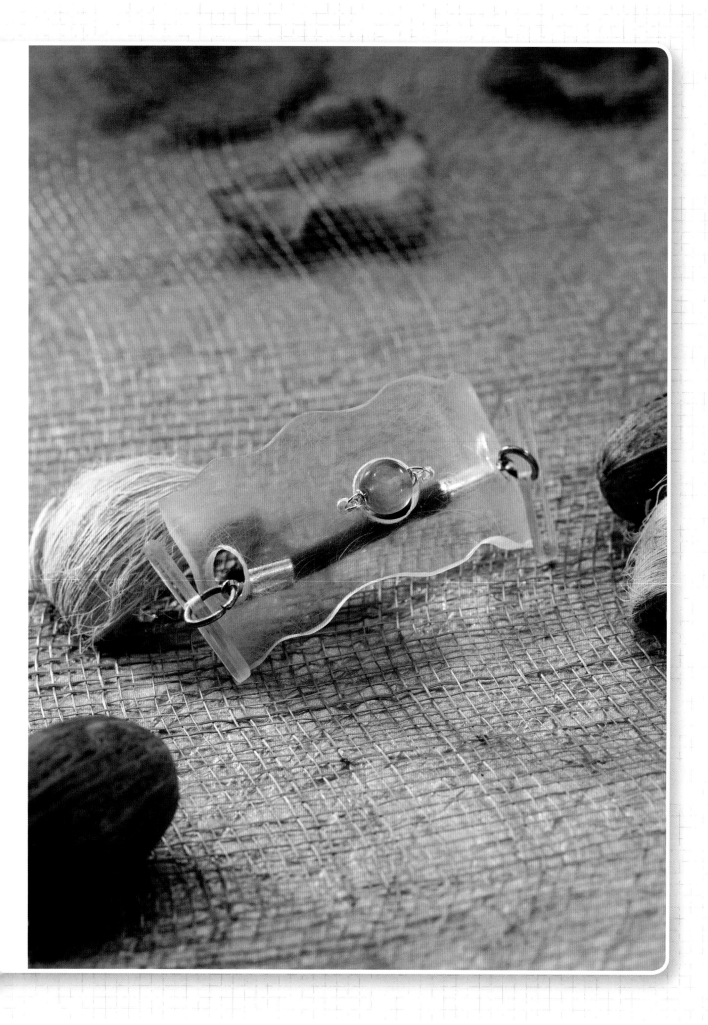

hold-me-back ponytail holder

Need a last-minute, knockout accessory for a special hairstyle? This project can snazz up any everyday ponytail, but it could also be taken to a sleek, sophisticated level. Simply replace the glass bead with a pearl and leave the lines around the Plexiglas straight. Depending upon the thickness of your hair, you may wish to either lengthen or shorten the length of elastic I used for the toggle.

materials

1¼" × 3" (3cm × 8cm) piece of Plexiglas

2 1" × ⅛" (3cm × 3mm) Plexiglas strips

elastic hair band

glass bead

2 ribbon crimps

about 5" (13cm) silver-colored 22-gauge wire

about 5" (13cm) 18-gauge wire

assorted circular templates

fine-grit sandpaper

Dremel tool with sanding attachment

silicone craft sheet

heat gun

wire cutters

needle-nose pliers

hand drill

¹/₁₆" (2mm), ³/₁₆" (5mm) and ⁵/₁₆" (8mm) drill bits

ruler

aluminum can

marker

scissors

variation

Beads and wire aren't required to make a dramatic statement.

1›› Sand and shape Plexiglas

Sand both sides of the 1¼" × 3" (3cm × 8cm) Plexiglas piece with a fine-grit sandpaper. Using the Dremel tool with the sanding attachment, carve little circular waves around the perimeter of the Plexiglas.

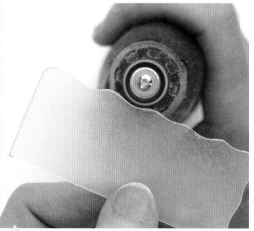
ONE

2›› Mark and drill holes

Measure the diameter of your bead, and select a circular template with a diameter that's slightly larger (a ⁵/₁₆" [8mm] circular template is shown here). With a marker, trace the template onto the center of the Plexiglas. Freehand mark 1 tiny dot to the left and 1 to the right of this circle. Then, at the center of each end of the pieces trace a ³/₁₆" (5mm) circle. Drill through each of these marks. For the center circle, start with a small drill bit and work your way up to a ⁵/₁₆" (8mm) drill bit. For the dots on either side, use a ¹/₁₆" (2mm) bit, and for the circle at each end, use a ³/₁₆" (5mm) bit.

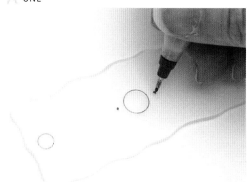
TWO

3›› Heat and curve Plexiglas

Lay the Plexiglas on the silicone craft sheet, and heat it with a heat gun until it is pliable, being careful to keep the gun moving so as not to concentrate the heat in any one spot. Pick up the plastic, and using an aluminum can or something else with a curved edge as a guide, shape it into an arc. Be careful handling the plastic—it will be hot.

THREE

4›› Wire focal bead into center hole

Take the 5" (13cm) piece of 22-gauge wire and thread it through the bead. Thread 1 end of the wire through the hole on the right from the front to the back, and the other end through the hole on the left from the back to the front.

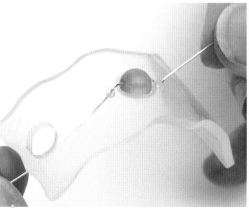
FOUR

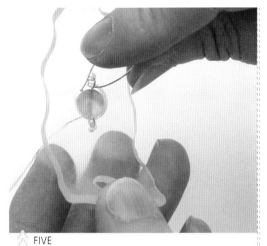

FIVE

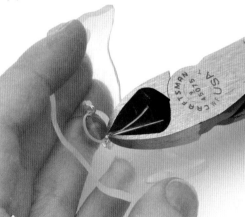

SIX

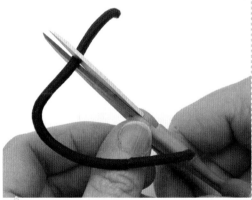

SEVEN

5›› Wrap wire to secure bead

Wrap the lengths of wire, still in opposite directions, through the hole that contains the bead. Wrap each length of wire around itself once, and pull it taut.

6›› Finish wiring focal bead

Thread each end of wire back through its respective hole to the front and left of the bead. Wrap each end around the wire adjacent to the bead again. Use wire cutters to trim off the ends. Use pliers to press any sharp edges flush against the Plexiglas.

7›› Sand and drill toggles and cut elastic

Drill a hole in the center of each of the 1" × ⅛" (3cm × 3mm) strips of Plexiglas with a ¹⁄₁₆" (2mm) bit. Use sandpaper or a Dremel tool to sand all sides, corners and edges. Cut a piece of an elastic hair band to 1¾" (4cm).

8›› Attach ribbon crimps

Use pliers to squeeze a ribbon crimp tightly to each end of the elastic.

9›› Make jump rings

Twist the length of 18-gauge silver-colored wire around your pliers, forming a loop about ¼" (6mm) in diameter. Cut with wire cutters to form a jump ring. Repeat to create a second jump ring. Flatten each jump ring with the pliers a bit to create more of an elliptical shape that will help it fit more easily through the holes in the Plexiglas. Attach each jump ring to both the end of the ribbon crimp and to the hole in the center of the Plexiglas toggle.

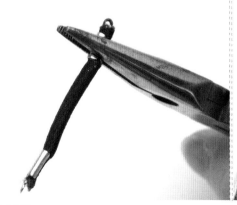

EIGHT

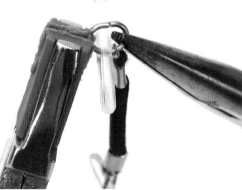

NINE

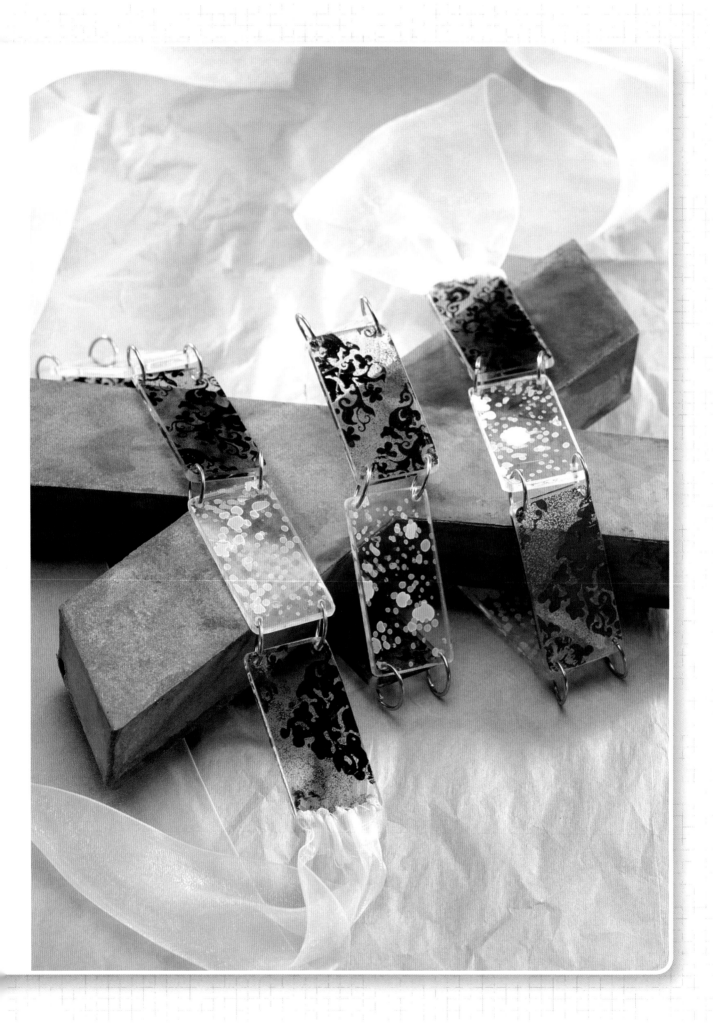

hot-linked belt

Modern and fashion-forward, this belt will have you thinking beyond leather
or chain for a show-stopping statement. The damask pattern could be replaced
with any stamp of your choice, and plain or patterned tissue paper could always
be added for color. For even more glamour, try embossing the Plexiglas in
metallic colors.

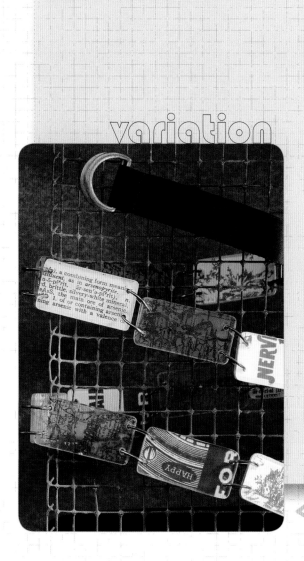

12" × 5" (30cm × 13cm) piece
of Plexiglas (to make 30 1" × 2"
[3cm × 5cm] belt links)

approx 4' (1m) galvanized 18-
gauge steel wire, or enough to
make 2 jump rings for each link
of the belt

approx 5' (1.5m) of 3" (8cm)
wide ribbon

hand drill

$^5/_{64}$" (1mm) drill bit

marker

metal cork-backed ruler

Super Marking Ink in white and
black (Stuart Superior)

rubber stamps (Damask Stamp
by JudiKins)

sponge or foam brush

plastic cutter

fine-grit sandpaper, or Dremel
tool with sanding attachment

pliers

painter's tape

sewing needle

thread

large knitting needle, about
$^7/_{16}$" (1cm) in diameter

measuring tape

circular template (optional)

wire cutters

*Short on stamps? Sandwich paper scraps
between two pieces of plexi.*

1 ›› Draw and drill belt links

Start by measuring your waist (or the waist of the person who you are making the belt for). Considering that each link is 2" (5cm) long and there is ¼" (6mm) space in between links, determine how many links you will need to construct your belt. Rule the 12" × 5" (30cm × 13cm) piece of Plexiglas into 1" × 2" (3cm × 5cm) sections for at least as many links as you need. Use a marker, and if you wish, a circle template to mark the locations of holes in all 4 corners of each of the links. Drill through each mark using a ⁵⁄₆₄" (2mm) drill bit.

2 ›› Stamp pattern

Peel the protective coating off of the unmarked side of the Plexiglas. Adhere a piece of painter's tape across the middle of the Plexiglas to serve as a mask. Use a sponge or a foam brush to apply white Super Marking Ink directly to the rubber stamp of your choice, and stamp repeatedly on one masked-off half of the Plexiglas. When you are happy with the pattern you have created, use a different stamp and black Super Marking Ink to create a pattern in the same way on the other masked-off half. Let the ink dry.

3 ›› Separate and sand belt links

Use a metal cork-backed ruler and a plastic cutter to score each of the lines you drew in step 1. Break the pieces apart. Smooth and/or round the corners of each piece using fine-grit sandpaper and/or a Dremel tool with a sanding attachment.

4 ›› Begin to form jump rings

Wrap a length of wire tightly around a large knitting needle with a ⁷⁄₁₆" (1cm) diameter.

5 ›› Trim end of wire coil

Use wire cutters to trim the edge off of your wire coil.

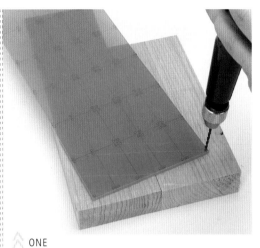

ONE

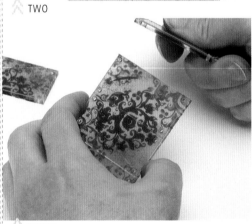

TWO

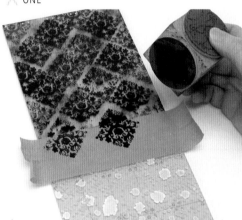

THREE

FOUR

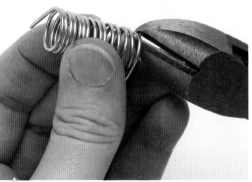

FIVE

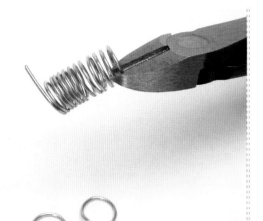

6›› Cut coil into jump rings

Use wire cutters to cut each loop of the coil apart into individual rings.

7›› Connect links with jump rings

Join 3 links at a time using the jump rings from step 6. Alternate between black and white links, and use pliers to close the rings after threading them through each pair of links. Continue until the belt is the desired length, just shy of closing around your waist.

8›› Hem ribbon closure

Drill 3 additional holes across each of the 2 end links, so each has a total of 5 holes across its edge. Cut your length of ribbon in half. Use a sewing needle and thread to hem 1 end of each ribbon to prevent it from fraying.

9›› Gather end of ribbon closure

Take a piece of ribbon and weave the thread through the hemmed end to gather it until it's roughly the same width as the edge of the belt. Repeat for the other piece of ribbon.

10›› Attach ribbon closure to belt

Use a needle and thread to sew a ribbon closure to the 5 holes in the edge of each end link of the belt.

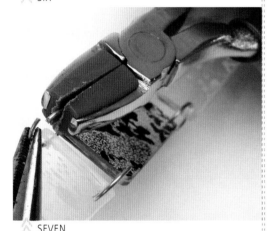

SEVEN

EIGHT

NINE

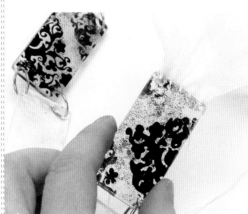

TEN

retail therapy checkbook cover

The sturdy surface of this cover makes it easy for you to write checks anywhere, anytime! Vinyl has long-term durability, even after you've shopped 'til you dropped. Any paper will work for this, but a thin paper like tissue or mulberry really works best. Feel free to substitute any coordinating fabric for the wrap closure.

2 3¹/₄" × 6⁵/₈" (8cm × 17cm) Plexiglas pieces

checkbook

patterned mulberry paper

approx 8" (20cm) of 1" (3cm) wide ribbon, or enough to wrap around checkbook cover

10¹/₄" × 7" (26cm × 18cm) piece of vinyl

³/₄" (2cm) square of Velcro

36 ¹/₁₆" (2mm) long eyelets

corner rounder

fine-grit sandpaper

Dremel tool with sanding attachment (optional)

hand drill

¹/₁₆" (2mm) drill bit

sewing needle or machine

scissors

marker

thread

brayer

paintbrush

matte medium

¹/₁₆" (2mm) eyelet setter

straightedge

plastic cutter

¹/₁₆" (2mm) hole punch

1›› Prepare Plexiglas panels

The 2 pieces of 3¼" × 6⅝" (8cm × 17cm) Plexiglas should cover a standard-sized checkbook; compare them to yours to be sure they are the correct size (if not, adjust accordingly). Sand both sides of each piece of Plexiglas, and round the corners using the sandpaper or a Dremel tool with a sanding attachment. Cut 2 pieces of patterned mulberry paper to a size slightly bigger than the pieces of Plexiglas. Use a paintbrush to apply matte medium directly to the Plexiglas. Dab the surface repeatedly with the brush to eliminate any visible brush strokes.

2›› Add decorative paper

Press the Plexiglas medium-side down onto the mulberry paper.

3›› Brayer and reapply matte medium

Flip the Plexiglas over, and brayer over the surface to smooth out any wrinkles or air bubbles in the paper. Use a paintbrush to apply another coat of matte medium to the paper. Let it dry.

4›› Sand edges clean

Sand the edges of the Plexiglas at a slight angle until the paper starts to rip away from the edges. Sand both pieces until the edges are completely clean.

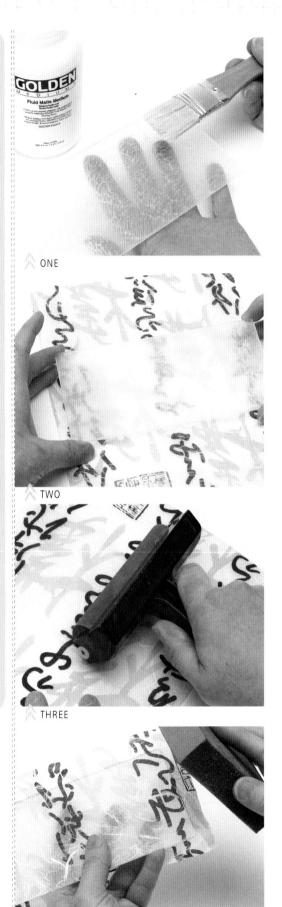

ONE

TWO

THREE

FOUR

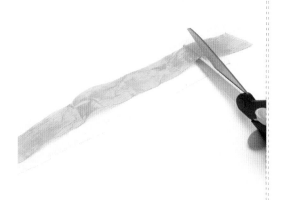

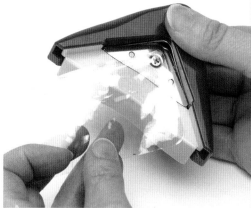

FIVE

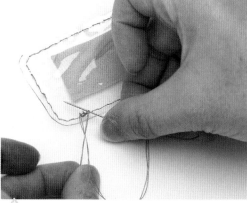

SIX

SEVEN

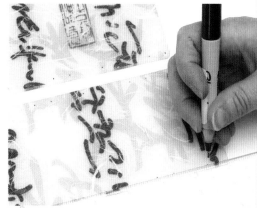

EIGHT

5›› Cut vinyl and ribbon for closure

Cut 2 pieces of vinyl to 10¼" × 2" (26cm × 5cm), making sure they're long enough to wrap completely around the checkbook. Cut a piece of ribbon to a slightly shorter length than the vinyl.

6›› Round corners of vinyl closure

Using a corner rounder, punch each corner of the vinyl to round it. If the rounder doesn't punch all the way through the vinyl, you might need to go over the punched line with scissors.

7›› Sew vinyl closure together

Sandwich the ribbon between the vinyl pieces, allowing the pressure-sensitive nature of the vinyl to hold the ribbon in place. Sew around the perimeter of the vinyl sandwich. If using a sewing machine, be patient—when the vinyl gets warm, it can get stuck in the feed dogs and be difficult to sew. If sewing by hand, sew freeform or measure stitch widths of ⅛" (3mm) around the edges and use a needle to prepunch each hole before sewing.

8›› Measure and mark eyelet holes

Use a straightedge and a marker to measure and mark for eyelet holes that will serve both as hinges for the checkbook cover and as a means of holding a vinyl pocket for the checkbook inside. I marked ten holes on one long side of each piece where the checkbook hinge will be, three holes on each side of the piece that will serve as the bottom and hold the vinyl pocket, and ten holes for the bottom edge and corners of the pocket. I evenly spaced my holes in pairs that were randomly spaced across the checkbook cover.

9›› Drill holes

Using a hand drill and a ¹/₁₆" (2mm) bit, drill all of the holes as marked. Drill from the paper side of each piece of Plexiglas to avoid ripping the paper.

10›› Cut and mark vinyl pocket and hinge

Cut a piece of vinyl for the pocket to 2" × 6⅝" (5cm × 17cm). Round the 2 bottom corners with the corner rounder. Cut a ⅞" × 6½" (2cm × 17cm) piece of vinyl for the hinge. Align the checkbook halves side by side, with about ¼" (6mm) of space in between, and lay the hinge piece of vinyl on top. Use a marker to mark where the holes will need to be punched into the vinyl to align with the holes that were drilled into the Plexiglas. Lay the pocket into position and use a marker to mark the location of those holes, as well.

11›› Determine closure placement

Measure the distance between the 2 center holes on the outside edge of what will be the bottom piece of the checkbook cover, and record this measurement. Then, measure 3½" (9cm) from the end of the ribbon sandwich, and use a marker to mark locations for the holes to be punched using the measurement you just recorded.

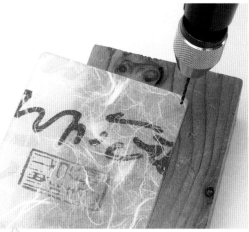

NINE

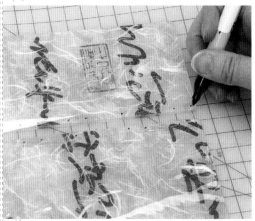

TEN

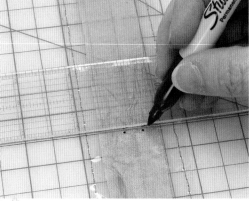

ELEVEN

12›› Punch holes in vinyl hinge and closure

Use a $\frac{1}{16}$" (2mm) hole punch to punch all of the eyelet holes into the vinyl pocket, hinge piece and closure piece.

13›› Set eyelets

Place the vinyl closure piece into position underneath the two halves of the checkbook cover, being sure to line up the holes. Lay the vinyl pocket and hinge pieces into position over the checkbook cover pieces, being careful to line up these holes, as well. One at a time, push an eyelet into each hole from the outside and use an eyelet setter to set each of the eyelets into place, being sure the eyelets fasten the vinyl to the Plexiglas where necessary.

14›› Adhere Velcro to closure

Close the checkbook cover and wrap the vinyl strip into position around the cover. Adhere a $\frac{3}{4}$" (2cm) square of a loop piece of Velcro into place in the center of the strip. Fasten the hook side onto the loop side, adhesive side up, remove the adhesive backing, wrap the other side of the strip snugly into place, and adhere the other half of the Velcro closure to the other side of the vinyl wrap.

Plexi Pointers

›› The nice thing about vinyl is it's stretchy. If any of your holes are punched slightly off the mark, it will be forgiving, and you should still be able to maneuver it into the proper position.

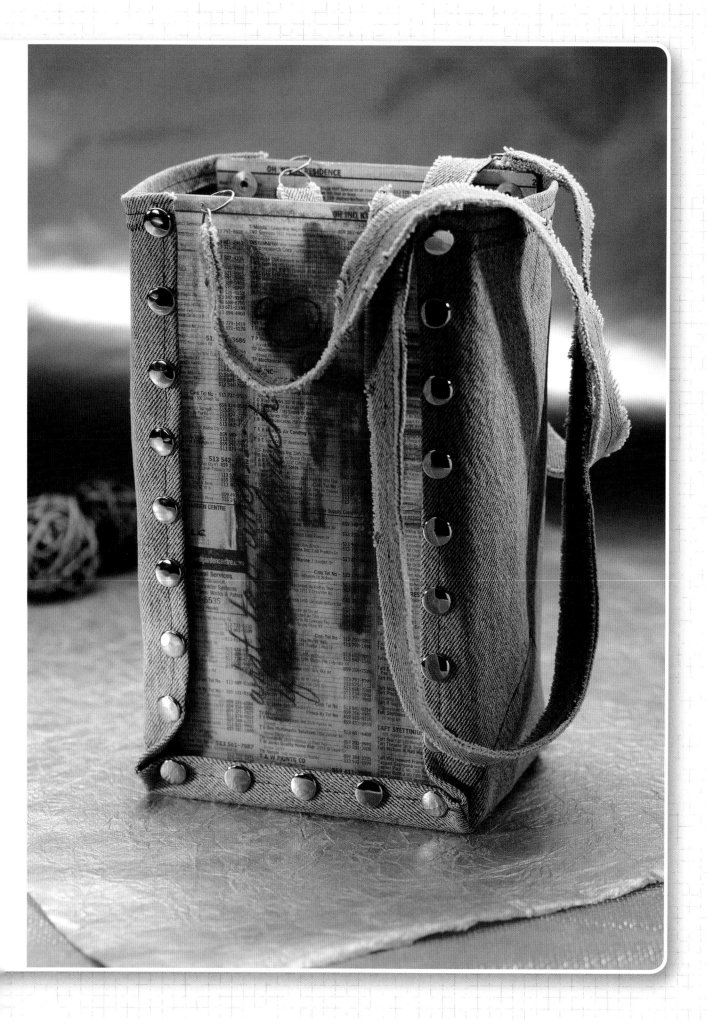

got your number tote bag

Repurposed blue jeans make this bag super soft, yet ultra durable. Silver snaps complement the casual look of denim, and Plexiglas becomes a clean slate for urban art or any other creative inspiration. I like that this bag celebrates the charm of the phone book before the wireless era makes them a thing of the past. But you can use any paper you choose, or leave the Plexiglas transparent and create vinyl straps for a more modern look.

materials

- 2 6" × 10½" (15cm × 27cm) Plexiglas pieces
- 2 pages torn from the phone book
- 6¾" × 27¾" (17cm × 71cm) piece of denim fabric (or fabric of your choice) for bag
- 4 30" × 1" (76cm × 3cm) strips of denim fabric (or fabric of your choice)
- 42 settable snaps (each comes in 3 pieces)
- approx 8" (20cm) 20-gauge wire
- watercolor crayons or paints and water
- charcoal pencil
- paintbrush
- ruler or measuring tape
- sewing machine (optional)
- sewing needle and thread

- hand drill
- ¹⁄₁₆" (2mm) drill bit
- fine-grit sandpaper
- masking tape
- marker
- pencil
- hammer
- awl
- eyelet setter
- ½" (1cm) diameter knitting needle
- wire cutters
- pliers
- matte medium
- brayer
- scissors
- craft knife

variation

For a more neutral look, try broadcasting yesterday's news front and center.

1›› Mark and drill holes in Plexiglas panels

With the protective cover on both pieces of the Plexiglas, lightly sand the corners smooth. With a marker, mark 9 evenly spaced holes down each long side of one panel, about ½" (1cm) from the edge and 1¼" (3cm) apart. On the top edge, mark 2 holes ⅛" (3mm) from the top and ¼" (6mm) from each side. On the bottom edge, mark 3 evenly spaced holes 1¼" (3cm) apart between the 2 bottom corner holes. Tape this marked piece flush on top of the other, and use a drill and a ¹/₁₆" (2mm) bit to drill through both layers at each mark. Remove the protective covers and sand both sides of both panels. Set them aside.

2›› Paint phonebook pages

Use watercolor crayons or paints to add color and a bit of design to the phonebook pages. Use the paintbrush to really work the water into the phone book paper to be sure it absorbs. Let dry. Use a charcoal pencil to add any additional elements you'd like to your design.

3›› Adhere pages to Plexiglas

Use a paintbrush to cover one side of each panel with matte medium, then press each panel onto the painted side of the phone book pages. Brayer the surface to eliminate any air bubbles or wrinkles, brush on another 2 or 3 coats of matte medium for extra durability, and let it dry. Sand the edges of any excess paper. Poke holes through the paper-coated side of each panel with an awl where you drilled holes in step 1.

4›› Cut and sew fabric for bag

Take your 6¾" × 27¾" (17cm × 71cm) piece of fabric, fold over the edges ½" (1cm) and sew down the center of each fold with a straight stitch to reinforce them. Zigzag stitch the edge of the folded allowance at each short end. Lay the strip flat, measure in 10¼" (26cm) from each end, and use a pencil to draw 2 vertical lines at each of these points. Sew along these lines. Then, mimicking fold lines like those on a paper bag, use a pencil and ruler to draw a small triangle outward from each of these lines, and then a horizontal line from the edge of each triangle to the end, as shown.

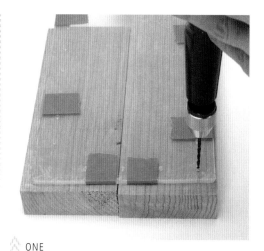

ONE

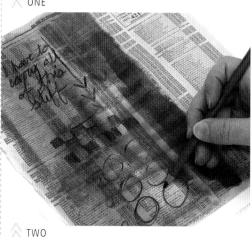

TWO

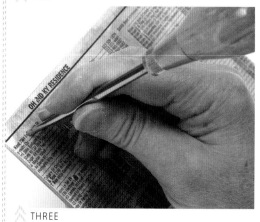

THREE

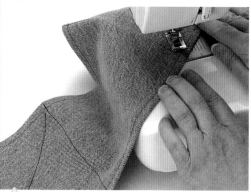

FOUR

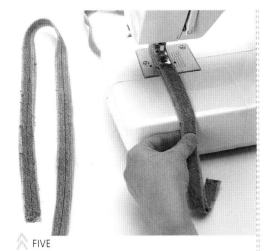

FIVE

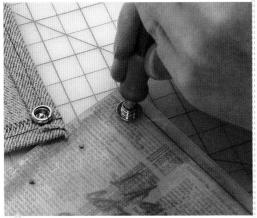

SIX

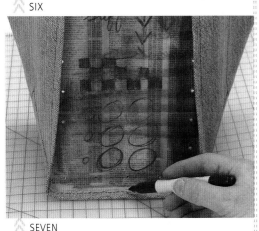

SEVEN

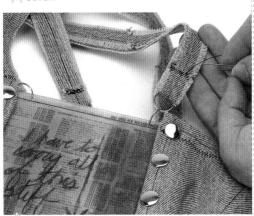

EIGHT

5›› Create straps

Cut 4 strips of denim to 30" × 1" (76cm × 3cm) and fray both long edges of each strip. Lay one strip flush on top of another and sew them together straight down the middle to create one strap. Repeat with the other two frayed strips to create a second strap.

6›› Align and set first corner snap

Line up one corner of the fabric with the top corner hole in one of the Plexiglas side panels. Use a pencil to mark the location of a corresponding hole in the corner of the fabric, and use your craft knife to make a tiny starter hole at that mark. Using an eyelet setter, set one part of the snap in the denim and the corresponding part of the snap in the Plexiglas. Repeat in the opposite corner.

7›› Set remaining snaps to assemble bag

Snap the two corners to the Plexiglas panel to ensure that the construction of your bag is lining up correctly. Use a pencil or marker to mark the fabric where the snap needs to be set at the bottom center. Once you have these three points established, continue in this manner until all of the snaps are set across each side and the bottom of the panel. Repeat with the other side panel on the other side of the bag.

8›› Attach straps

Wrap a piece of 20-gauge wire tightly around a ½" (1cm) diameter knitting needle 10 times, and use wire cutters to cut the wire coil into 8 jump rings. Loop 4 of the jump rings through the 4 holes at the top of the Plexiglas sides of the bag, and close them tightly with pliers. Loop an additional jump ring through each of those jump rings, and close them tightly. Fold one end of the first strap through one of the outer jump rings and use a needle and thread to sew it in place. Repeat until both straps are attached.

Plexi Pointers

›› If you don't have a drill press, drilling through two layers of Plexiglas may be difficult. If this is the case, you may want to mark and drill each piece separately.

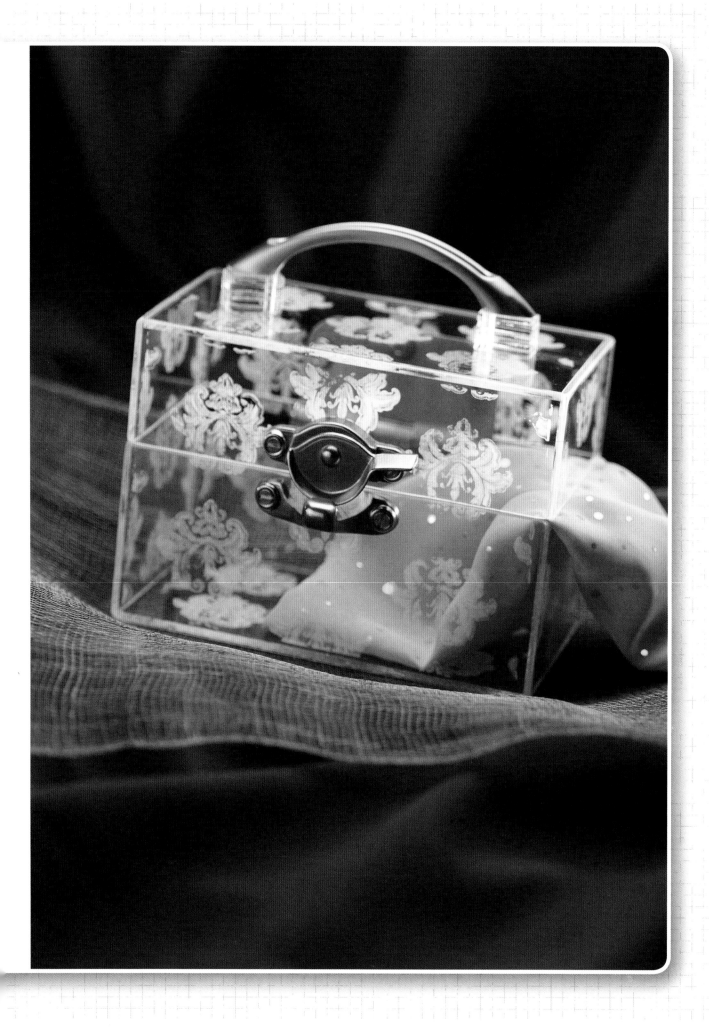

show-and-tell box purse

No need for security to open up this purse; show the world you have nothing to hide. (Or, if you're not feeling so daring, layer your stamping for a more opaque look, or cover the interior panels of this box with pretty paper.) The cabinet hardware really makes this purse a custom work—and it's available in an endless array of styles and finishes.

materials

Plexiglas, cut to the following dimensions:

- 2 pieces, 4" × 7" (10cm × 18cm)
- 2 pieces, 4" × 5" (10cm × 13cm)
- 2 pieces, 5" × 7" (13cm × 18cm)
- 10 pieces, ½" × 1" (1cm × 3cm)

cabinet handle

cabinet door hinge

cabinet latch

bolts and washers to fit the cabinet hardware

rubber stamp (Damask stamp by JudiKins)

white Super Marking Ink (Stewart Superior)

sponge or foam brush

disposable plate or bowl

measuring tape or ruler

fine-grit sandpaper

Dremel tool with sanding and cutting wheel attachments (optional)

hand drill

drill bit to match the size of the bolts that fit your cabinet hardware

screwdriver

jeweler's saw or hacksaw

marker

plastic cutter

metal straightedge with cork backing

vise

small piece of mat board (optional)

plastic cement

painter's tape

bolt cutters (optional)

1» Mask Plexiglas pieces

Peel the protective coating off of one side of each of the six Plexiglas pieces. If you'd like to sketch a grid for your stamping pattern, you can do it with a marker on the protective coating on the back side of the piece of plastic; it will show through, so you will be able to see it from the right side. Use painter's tape to mask the edges of each piece. Here I've let the mask do double duty by adhering the Plexiglas to my work surface to keep it steady.

ONE

2» Stamp pattern onto Plexiglas

Pour a bit of white Super Marking Ink onto a disposable bowl or plate. Use a sponge or a foam brush to dab the ink directly onto the rubber stamp. Stamp all 6 pieces of Plexiglas in the pattern of your choosing. Let them dry.

TWO

3» Mark holes for hardware

Determine where the hardware will go on the 5" × 7 3/16" (13cm × 18cm) pieces, which will become the front and back of the box purse. Flip these pieces over so the wrong side with the protective coating still on is facing up. Measure 2" (5cm) down from the top of each piece and draw a horizontal line with a marker. Position one piece at the very bottom of the top panel of the hinge over this line, and center the hinge horizontally. Trace the openings on both panels of the hinge to give yourself a guide for drilling these holes. Position the 2 parts of the latch on top of the second Plexiglas piece so they latch together at the line, and trace the openings to give yourself a guide for drilling these holes.

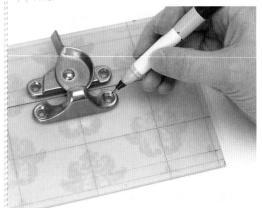
THREE

4» Drill holes

The cabinet hardware comes with screws, but those won't work with plastic, so find some bolts that will fit the holes in the hinge and latch. (If the bolts you choose are a bit thinner than the holes, you may want to use a washer to secure each bolt. If the bolts you choose seem to be too long, don't worry: We'll fix that in steps 14–15.) Using a drill bit that's the same size as the bolts, drill the holes in the locations you marked. Don't insert the bolts just yet.

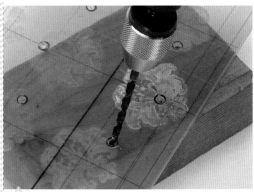
FOUR

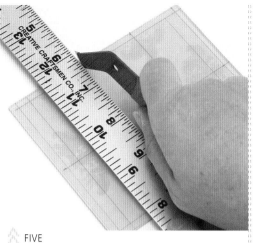

FIVE

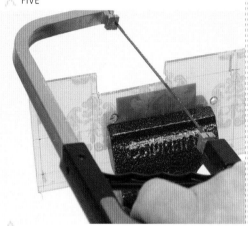

SIX

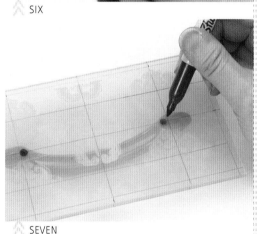

SEVEN

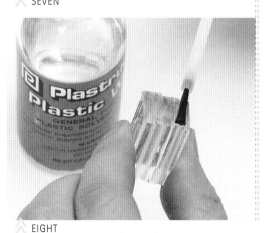

EIGHT

5›› Score and break side pieces

The two 4" × 5" (10cm × 13cm) pieces will serve as the sides of the purse. Flip these pieces over so the wrong side with the protective coating still on is facing up. Measure 2" (5cm) down from the top of each piece and draw a horizontal line with a marker. Using a straightedge and a plastic cutter, score and break these pieces along this line. Do the same to the front and back pieces.

6›› Cut opening for hinge joint

Lay the hinge in position on the 2 back pieces of the purse. Mark the 2 sides of the center pin of the hinge, then draw a line connecting these points just below the bottom edge of the center pin. With a $^7/_{64}$" (3mm) bit, drill a small hole in the middle of the horizontal line (this hole will give your saw room to turn). Use a jeweler's saw or hacksaw to cut along the vertical lines, then cut a vertical line down to the hole you drilled, then horizontally along the bottom line. When you're done, you'll have an opening for the center pin of the hinges to fit snugly into when the purse is assembled.

7›› Mark and drill holes for handle

Center the handle beneath the piece that will become the top of the purse. With the wrong side up, mark where holes will need to be drilled to attach each side of the handle. The handle should have come with bolts to attach it to the purse, so choose a drill bit to match their thickness, and drill 2 holes through your marks.

8›› Make Plexiglas stacks

Gather the 10 ½" x 1" (1cm x 3cm) Plexiglas pieces. Use the applicator to brush plastic cement one by one onto each piece until you've glued 5 pieces, one flush on top of another, together in an even stack. Repeat to form a second stack of 5 pieces. Let them cure.

Plexi Pointers

›› You may want to line up and cut all the side pieces of the box purse at once. This way you can be absolutely certain that the lid and the base are perfectly even.

9›› Mark holes in handle supports

Hold one of the stacks against the edge of your handle, and mark the location of the hole in the handle. Do the same with the other small stack.

10›› Drill and sand handle supports

Using the drill bit that matches your handle's bolts, drill a hole through each small stack of Plexiglas. Use fine-grit sandpaper to sand the corners of each stack until they're smooth. Note: If using a hand drill, you may need to start with a 1/8" (3mm) bit and gradually progress to larger bits until your holes are the size you need.

11›› Adhere panels together

Peel the protective sheets from all the box's panels. Start with the bottom panel, with the stamped side of this piece (and all others) facing the inside of the purse. Use the applicator to brush plastic cement along one short edge, and press one side panel into place, centering it on the side edge of the bottom panel. Hold the two together for a few seconds to allow the cement to set. Repeat with a longer piece, creating the outer corner where it meets the short piece. Continue in this way until the bottom part of the purse is assembled. Then, starting with the top panel, repeat to form the lid. Let the glue cure completely.

12›› Sand all corners and edges

Use a Dremel tool and/or a fine-grit sandpaper to sand all of the corners of both the box and the lid until it's not obvious where the seams come together and all edges are smooth. Rinse the box in the sink until all the plastic particles are washed away, and let it dry.

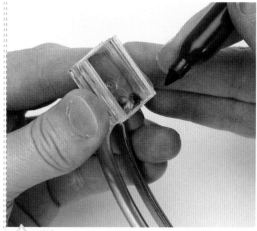

NINE

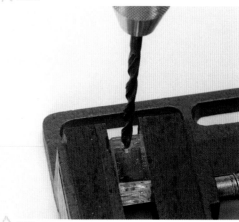

TEN

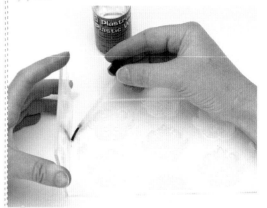

ELEVEN

TWELVE

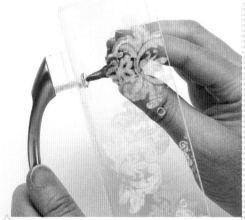

13» Attach handle

Line up the holes in the 2 small Plexiglas stacks you created in step 10 with the holes in the top of the lid. Place the handle on top. Screw the bolts through all 3 items until the handle is firmly attached to the lid.

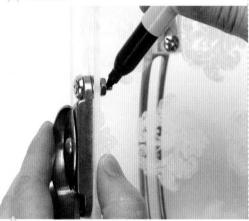

FOURTEEN

14» Mark desired length of bolts

Place one of the bolts you purchased for the latch and hinge through both the hole you drilled through the box and the hardware it will be holding, and, if it is too long, use a marker to mark the length it will need to be so as not to protrude into the purse. Mark each of the other bolts in the same manner. (If your bolts are already the correct length, skip to step 16.)

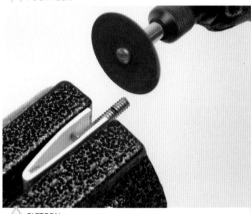

FIFTEEN

15» Cut bolts to size

Place one of the bolts in a vise, and use a Dremel tool with a cutoff wheel attachment to cut the bolt at the mark. (If your bolt seems to be slipping out of place in the vise, try wrapping it in a small piece of mat board, as I did here.) If you don't have a Dremel tool and a cutoff wheel, you can also use either a hacksaw or bolt cutters for this step. Repeat until all of the bolts have been cut to size.

16» Attach hardware to purse

Use the bolts and nuts to attach the latch and hinge tightly to the box purse.

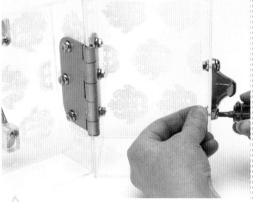

SIXTEEN

Plexi Pointers

If you're having a hard time lining up the sides just right, remember that it's more important for them to be exactly flush where the lid and the box meet than it is for them to perfectly align at the top and the bottom of the box. If you end up with a small excess edge at the top or bottom, you can sand that off later using a Dremel tool or sandpaper.

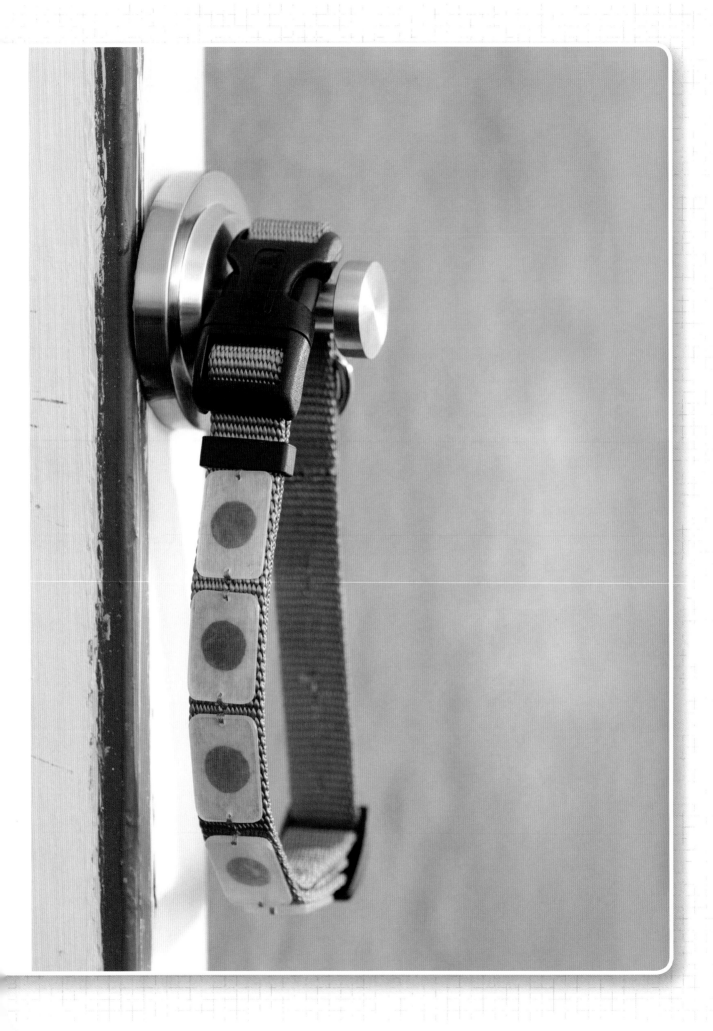

haute dog collar

Fashion your own canine couture with this easy collar of Plexiglas charms. While this is really intended as more of a "party collar" for special occasions, if you want your best friend to be able to wear it 24/7, just make certain the charms are sewn on extra securely to ensure they don't pose a choking hazard.

variation

Express hugs and kisses in doodles of wire: Just drill and wrap.

materials

dog collar

approximately 1" × 10" (3cm × 25cm) piece of Plexiglas, depending on size of collar (see step 1 for further instruction)

red mulberry paper

light blue tissue paper

$^3/_8$" (1cm) diameter circular stencil or template

sewing needle

heavy-duty thread, such as carpet thread

matte medium

scissors

fine-grit sandpaper

Dremel tool with sanding attachment (optional)

hand drill

$^1/_{16}$" (2mm) drill bit

drill press or vise

hot knife or plastic cutter and straightedge

paintbrush

marker

ruler or measuring tape

1›› Adjust and measure collar

Adjust the dog collar so it fits your dog. (The collar will not be adjustable once the Plexiglas charms are attached, so the collar must be the correct size before you begin.) Measure the width of the collar so you know how wide to make your Plexiglas charms. Then measure length-wise to determine how many 1" (3cm) long charms you will need to fill the collar, leaving a tiny bit of space between each one.

2›› Create collar charms

Measure and cut a piece of Plexiglas to the width of the collar, then cut it into 1" (3cm) strips (a hot knife is best, but a plastic cutter will also work) until you have as many as you need. Round the edges of each charm using fine-grit sandpaper or a Dremel tool with a sanding attachment. Sand both sides of each piece. Using a ⅜" (1cm) diameter circular stencil or template, trace 1 circle on red mulberry paper for each charm. Cut out the circles.

3›› Decorate charms with tissue paper

Brush one charm with matte medium and place a red mulberry circle in the center. Brush matte medium over the surface again, then press a piece of light blue tissue paper that is slightly bigger than the charm itself onto the surface. Brush over the surface with matte medium once more, using the brush to work out any wrinkles or air bubbles. Repeat for each charm. Let all the charms dry.

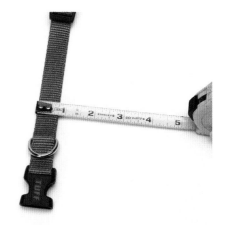

ONE

TWO

THREE

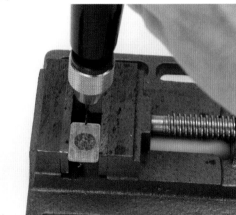

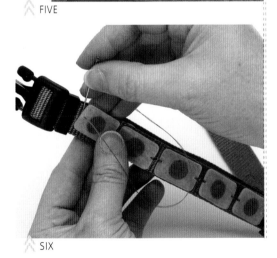

4›› Sand edges clean

Sand the edges of the charms until all the remaining paper flakes off, forming clean edges.

5›› Drill holes in each charm

Lay one charm paper-side up, and make a light mark in the center of each short side, about ¹⁄₁₆" (2mm) from the edge. Clamp the charm in a drill press or, if you don't have one, a vise with the paper side up. Using a hand drill and a ¹⁄₁₆" (2mm) drill bit, drill a hole at each mark. Repeat for all of the charms.

6›› Sew charms to collar

Lay all of the charms on the collar to determine placement, then set them aside. Starting at one end of the collar, sew the first charm onto the collar. Sew through each hole in each end of the charm several times, being sure the charm is very secure so that it can take the wear and tear of being worn by the dog without coming loose. Once the charm is fastened, use the needle to push the thread underneath the collar and up through to the location of the next charm. Repeat until all charms are attached.

FOUR

FIVE

SIX

high-elevation coasters

These coasters are so easy to make that a stack of four would make a perfect last-minute hostess gift. The holes in the top layer make for a fun design while allowing condensation to drain away.

materials

2 4" (10cm) squares of Plexiglas per coaster	4 4-40×½ nuts per coaster	Dremel tool with sanding attachment (optional)
4 ½" (1cm) squares of Plexiglas per coaster	4 rubber bumpers per coaster	hand drill
green tissue paper	graph paper	7/64" (3mm) drill bit
4 4-40×½ flat-head screws per coaster	fine-grit sandpaper	pencil
	matte medium	marker
	masking tape	paintbrush

1›› Create design for coaster

Use fine-grit sandpaper to sand both surfaces of the 4" (10cm) Plexiglas squares. Using a Dremel tool or sandpaper, round the corners. Choose a square to be the top coaster piece, lay it on graph paper, and use a pencil to trace it. Then, inside the traced area of the graph paper, draw a pattern of tiny circles—these will become decorative holes drilled through the top coaster piece. Be sure your design includes one mark in each corner. Then, position the coaster over the marks and use a marker to transfer each mark onto the Plexiglas. Using a 7/64" (3mm) bit, drill a hole through each mark.

ONE

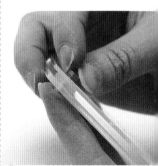

TWO

2›› Drill corners in bottom piece

Tape the top coaster piece flush on the bottom piece. Place the drill bit into each of the corner holes and drill through the bottom layer.

3›› Create spacer pieces

Sand both sides of each ½" (1cm) Plexiglas square. Use the sandpaper or a Dremel tool with a sanding attachment to round the corners until the pieces are almost circles. Brush matte medium on 1 side of each piece, and press each one down onto a slightly bigger piece of green tissue paper. Brush another coat of matte medium on the tissue-paper side of each piece. Let dry. Sand the excess paper off of each. Drill a hole through the center of each.

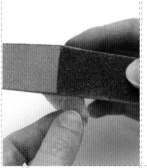

THREE

FOUR

FIVE

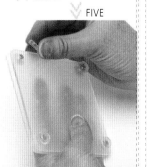

4›› Assemble coaster

Lay the bottom coaster piece on your work surface, and place one of the smaller pieces in each corner, aligning the holes. Place the other coaster piece on top, aligning the corner holes. Insert a screw from the bottom up through all 3 layers at each corner, and twist the nuts on securely from the top side.

5›› Add protective bumpers

Peel and stick protective bumpers over the head of each screw.

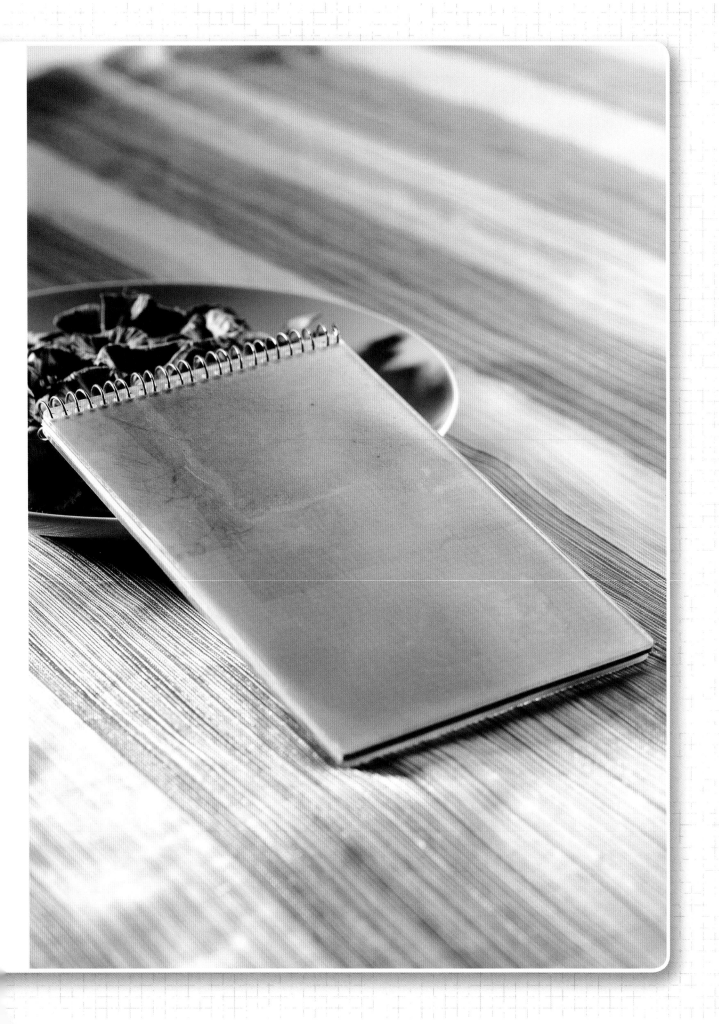

take note notepad cover

Whether you're at the office or in the grocery store, others will take note
of your uniquely handcrafted notepad cover. The cardboard covers of
traditional steno pads can be difficult to write on, and when everyone in
the office has the same one, it can be easy to lose your notes in the shuffle.
Take the doldrums out of your next board meeting with this spiffy project
that will make you the envy of everyone in your department.

*Remember doodling
during lectures? Or
during long phone
calls? Try doodling a
cover for a journal
instead of a note pad.*

materials

2 pieces of Plexiglas cut to the exact size of
the cover of the steno pad

steno pad

assorted tissue papers

spool of 18-gauge wire

wire cutters

½" (1cm) diameter knitting needle

paintbrush

marker

fine-grit sandpaper

Dremel tool with sanding attachment (optional)

pliers

2 small clamps

hand drill

$^9/_{64}$" (4mm) drill bit

awl

matte medium

tape

brayer

1 ›› Remove coil from pad

Tape the sides of the steno pad tightly to hold it securely together. Use wire cutters to cut the crimped ends off of the wire coil at the top of the pad, and unravel the coil from the pages. Discard the wire coil.

2 ›› Trace holes onto Plexiglas

Peel off the tape, and remove the steno pad's cover and the cardboard backing. Keep the pages of the pad held together. Lay a piece of Plexiglas flush on top of the cardboard backing, and tape them together. Use a marker to trace each of the holes across the top onto the Plexiglas. Discard the cover and cardboard backing.

3 ›› Drill holes on both panels

Use a hand drill and a %4" (4mm) drill bit to drill through each hole you marked in step 2. Lay this piece of Plexiglas flush on top of the other piece and tape them together. Carefully use the top piece as a template to drill holes across the top of the bottom piece.

4 ›› Adhere decorative paper collage

Use a fine-grit sandpaper to sand both sides of both pieces of Plexiglas. Use the sandpaper or a Dremel tool with a sanding attachment to smooth the edges and corners. Cut or rip some papers that complement each other, and arrange them on your work surface in a layered collage until you like the results. Brush matte medium on the back of one of the Plexiglas panels, dabbing the brush to eliminate any strong brush strokes. Press the bottom layer of collage elements into place, brayer (if your papers are big enough to allow you to do so without getting matte medium all over your brayer), and top with another coat of matte medium. Continue in this fashion until your collage is complete. Finish with a final coat of matte medium and let it dry. Sand the edges to eliminate any excess paper. Repeat for the other panel.

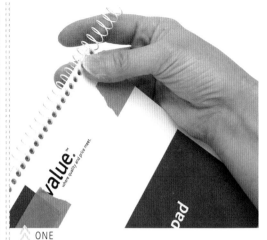

ONE

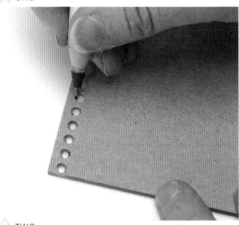

TWO

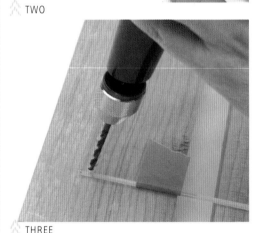

THREE

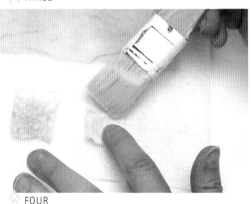

FOUR

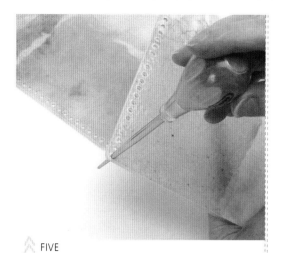

FIVE

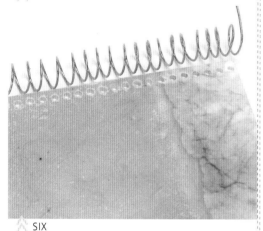

SIX

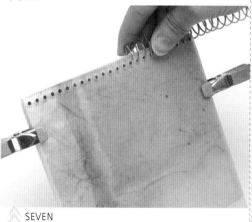

SEVEN

5›› Punch holes through paper

Use an awl to poke clean holes down through the paper-coated side of each panel where you drilled holes in the Plexiglas in step 3.

6›› Create new spiral binding

Count the number of holes in your steno pad. Start unwrapping wire from the spool and wrapping it tightly in a coil around the knitting needle until you have the same number of coils as there are holes in your steno pad. Leave about ½" (1cm) of extra wire at the end before cutting it with the wire cutters. Stretch the coil out to about the width of the pad.

7›› Reassemble pad with new covers

Place the plastic covers on either side of the steno pad, lining up the holes at the top, and clamp both sides together. Trim 1 end of the wire to the beginning of the coil. Thread your wire coil through both covers and the pad until it is reassembled. Use pliers to crimp both ends of the coil so it will not unwind.

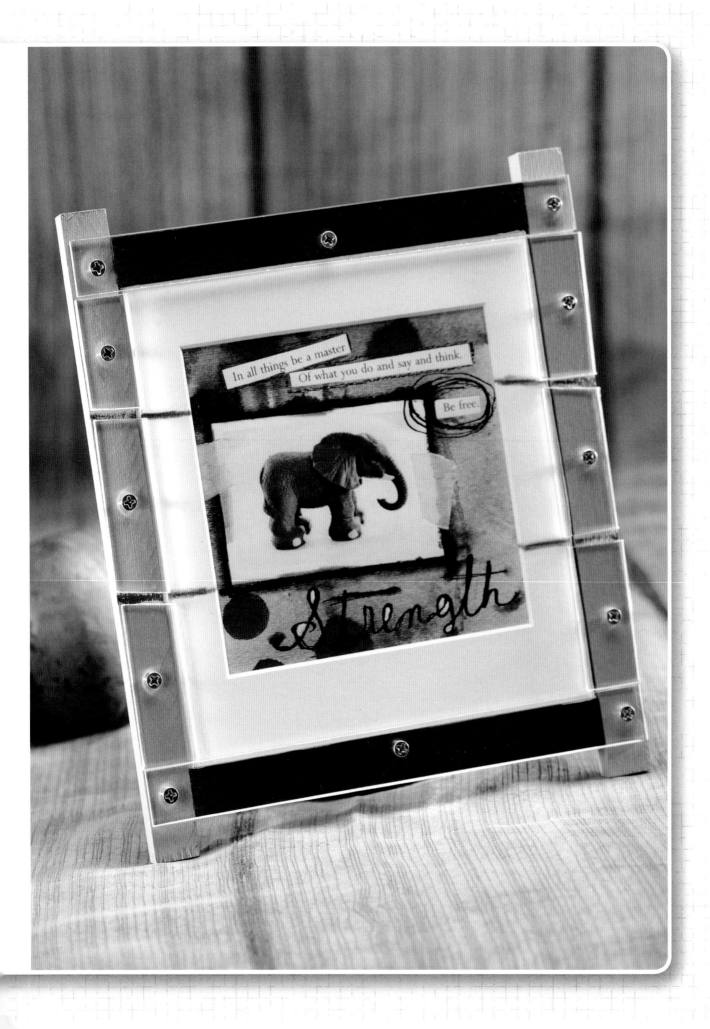

In all things be a master
Of what you do and say and think.

Be free.

Strength

perfect presentation frame

Custom framing doesn't get much easier than this. Simple wood trim molding is cut without a miter and can be trimmed to any size, while strips of Plexiglas fill in for the rabbit (the ledge that holds in the artwork). An easy adaptation would be to cut a single sheet of Plexiglas to cover the entire frame and artwork and forego the smaller piece and strips. Either way, this frame is a work of art in and of itself.

materials

photo or artwork of your choice
(mine was matted to 6½" × 7⅛" [17cm × 18cm])

photo mat (optional)

trim molding, enough to frame your photo in the manner described (I used about 34" [86cm])

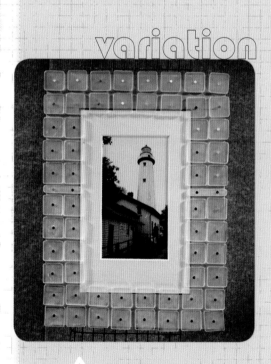

variation

This variation is just as simple, but requires a little more patience: Create Plexiglas tiles, drill through the centers and nail them to a painted wood frame.

1 sheet of Plexiglas cut to cover your photo, and 4 strips cut to cover frame

foamcore (enough to back the artwork to be framed)

12 screws, shorter than the thickness of your frame

saw-tooth hanger

acrylic craft paint in colors of your choice

ruler or tape measure

hot knife

small circular saw

paintbrush

pencil

point driver, or hammer and 6 nails

artist's tape

wood glue

hand drill

drill bit in a size that matches your screws

screwdriver

clamp (optional)

marker

(Elephant print by Linda Woods)

1 ›› Tape elements to be framed together

Start with an image you'd like to frame. I elected to mat a piece of artwork and to embellish the mat with pencil lines, but feel free to frame a photo rather than artwork and/or to leave your mat plain if you prefer. Cut a piece of foamcore backing to fit behind your matted image, and cut and remove the protective cover from a piece of Plexiglas to lay on top. Carefully align all of the layers, and use artist's tape to bind all of the elements together. Rip off a piece that's a little bit longer than the side you're going to tape, lay the piece on its side and line up the tape right alongside the glass. Press the tape down the side and wrap it around the back of the foamcore and around the ends of the corners to secure it in place. Repeat for all 4 edges.

2 ›› Burnish tape

Use your fingernail to burnish the tape firmly into place so it does not dry out and separate from the edge later. Repeat for all 4 edges.

3 ›› Cut trim molding for frame

Cut 4 pieces of ¾" × ½" (2cm × 1cm) trim molding to build your frame. Cut 2 pieces to exactly the width of your frame, and 2 pieces that extend ½" (1cm) below the artwork and ⅜" (1cm) above it. Use a tiny circular saw to cut the pieces.

4 ›› Paint frame pieces

Paint all four sides of each piece of trim molding. Let them dry.

5 ›› Mark corners of frame

Line up the pieces of the frame the way you want them to be, and using a tape measure as a guide, use a pencil to lightly mark where you're going to glue the pieces together.

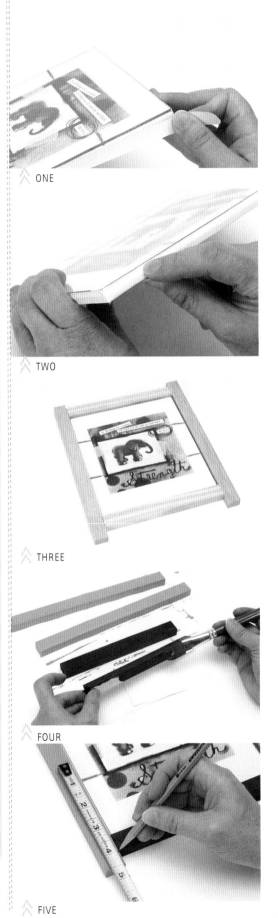

ONE

TWO

THREE

FOUR

FIVE

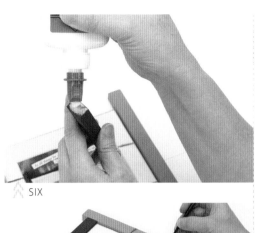

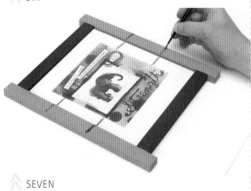

SEVEN

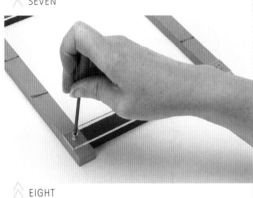

EIGHT

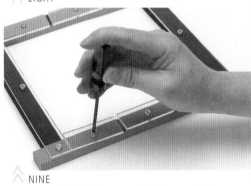

NINE

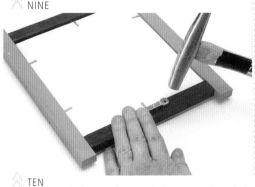

TEN

6›› Glue frame together

Use wood glue to glue the four pieces of the frame together. Make sure the pieces are flush where they meet. Wipe off any excess glue that oozes out. Let the frame dry. If you'd like, you can clamp the pieces together while they're still wet to ensure a firm bond.

7›› Add detail with paint

Paint any additional decorative elements on your frame to complement the photo or artwork inside.

8›› Add Plexiglas strips to frame

Cut 2 strips of Plexiglas to the width of the entire frame and a length of ⅞" (2cm). Lay these strips, with the protective covers still on, on the top and bottom pieces of the frame, allowing the plastic lip of each strip to extend over the interior of the frame, and use a marker to mark three locations at the center and edges of each strip where you will screw it to the frame. Using a drill bit that matches the size of your screws, drill holes through your marks in each strip. Remove the protective cover from both strips, and screw them into the frame.

9›› Add vertical strips to frame

Cut 2 more ⅞" (2cm) wide strips of Plexiglas to the height of the exposed sides of the inner frame. If you'd like, to add visual interest, mark the location of any decorative elements you painted in step 7, and then cut the Plexiglas with a hot knife and break it at this spot to leave the element uncovered, as I did here. Lay the strips into position, then mark and drill them as in step 8. Remove the protective cover from both strips and screw them into the frame.

10›› Secure artwork in frame and add hanger

Use a point driver, or if you don't have one, a hammer and 6 nails, to secure the artwork into the back of the frame. To finish, nail a saw-tooth hanger into the center of the top back of the frame.

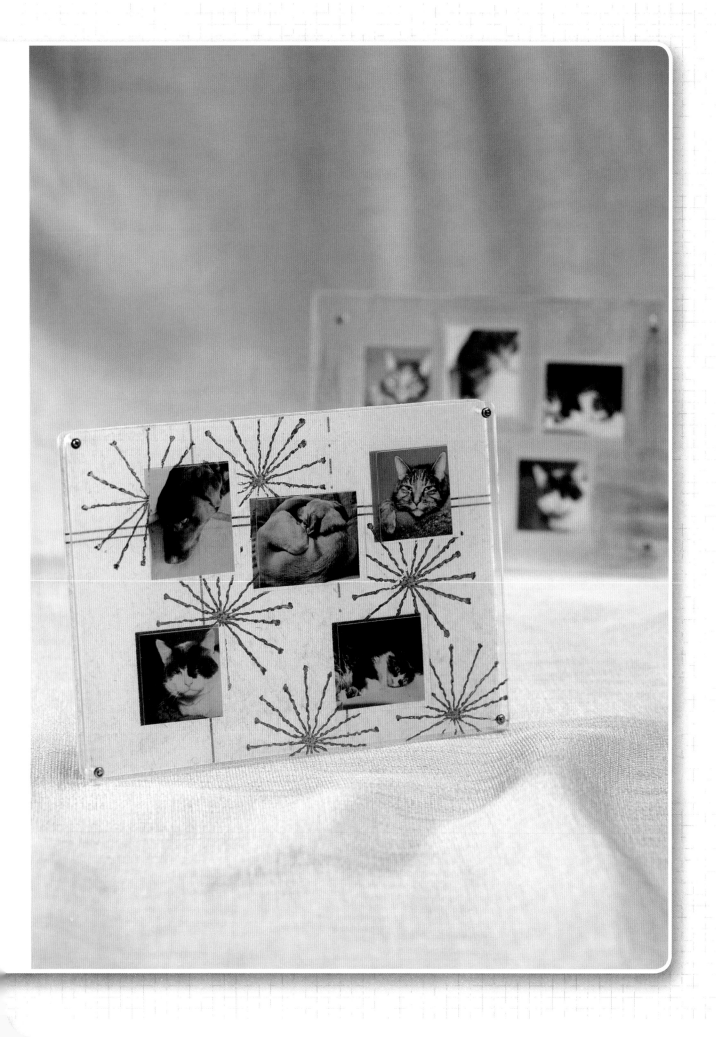

cubicle envy frame

Just because you work in a fabric-lined box doesn't mean you have to sacrifice sophisticated framing and resort to pushpins. This attractive frame is extremely lightweight, yet it rivals fancy store-bought frames—and, in fact, comes out ahead. For a matted look, try painting the inside of the top piece (over the mask) instead of stamping it. Make one as a gift for your boss, and she's sure to nominate you for Employee of the Month.

materials

photos you wish to frame

2 5" × 7" (13cm × 18cm) Plexiglas pieces

patterned tissue paper

4 $^1/_{16}$" (2mm) screws

4 $^1/_{16}$" (2mm) nuts

4 $^1/_{16}$" (2mm) washers

4 spacer beads

saw-tooth hanger

fine-grit sandpaper

Dremel tool with sanding attachment (optional)

paintbrush

brayer

craft knife

hand drill

$^1/_{16}$" (2mm) drill bit

straightedge (preferably a metal ruler with cork backing)

marker

scissors

Antique Silver Accent Powder (Stewart Superior)

Stamp & Stick Gluepad Kit (Stewart Superior)

rubber stamp

heat gun

clear spray sealer

matte medium

epoxy

rubber band

variation

No paper, no stamps—just a clean and frosty finish.

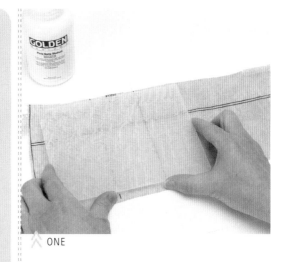

1›› Begin to create bottom layer of frame

Sand both sides of a 5" × 7" (13cm × 18cm) Plexiglas piece using a fine-grit sandpaper and smooth the edges using the sandpaper or a Dremel tool with the sanding attachment. Use a paintbrush to apply matte medium to one side, dab the brush to eliminate the heavy appearance of brush strokes and press the plastic firmly down onto a piece of patterned tissue paper that is slightly bigger than the Plexiglas. Use a brayer to smooth out any wrinkles or air bubbles. Brush another coat of matte medium on top of the tissue paper and let it dry.

ONE

2›› Sand edges smooth

Sand the edges until all of the paper rips away and forms a clean edge.

3›› Add photos

Place the Plexiglas paper-side up on your work surface. Cut out a few photos you'd like to frame and use matte medium to adhere them to the paper.

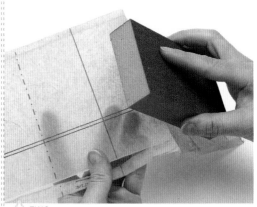

TWO

THREE

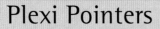

Plexi Pointers

›› You can speed up the drying of matte medium with a heat gun or hair dryer if you wish.

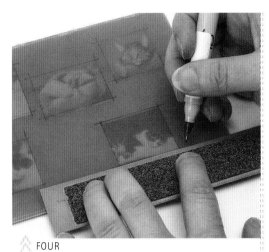

FOUR

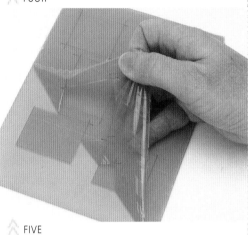

FIVE

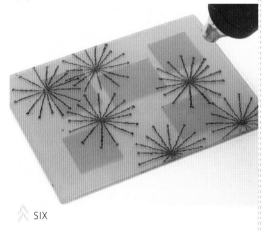

SIX

4›› Begin to create top layer of frame

Lay a second 5" × 7" (13cm × 18cm) Plexiglas piece flush on top of the piece containing the photos. Trace around the edges of each photo using a marker and a straightedge.

5›› Create mask on top layer of frame

Using a craft knife and a straightedge, carefully cut around the lines you drew in step 4. Try not to use too much pressure, or to overcut the corners. Peel the excess protective covering away, leaving a mask of the protective covering above the location of each photo.

6›› Stamp and heat glue

Using a rubber stamp and the Stamp & Stick Gluepad Kit, randomly stamp an image repeatedly over the piece of Plexiglas until you've established a pattern you like. Use a heat gun to set the glue until it becomes tacky. Be careful not to focus the heat too much on one area (if you do, you might start to melt and bow the plastic).

7» Add antique powder

Sprinkle the Antique Silver Accent Powder over the stamped areas and work it into the glue with your fingers until the stamped areas are fully colored.

8» Remove excess powder

Use a paintbrush to remove any excess powder.

9» Seal surface

Spray the entire surface with a clear sealer so the stamped images are protected.

10» Drill holes in corners of frame

Use a marker to make a dot for a hole in each corner of the Plexiglas. With a ¹⁄₁₆" (2mm) drill bit, drill a hole through each mark. Place this piece of Plexiglas flush on top of the piece containing the photos and bind them together with a rubber band. Place the bit of the drill into each of the holes you just drilled, and drill through the second layer of Plexiglas.

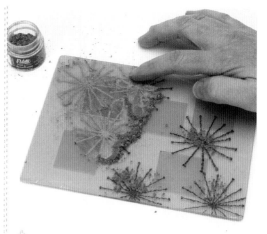

SEVEN

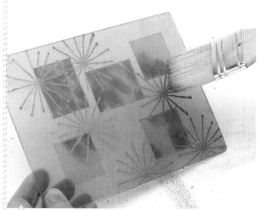

EIGHT

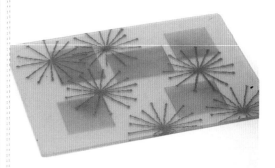

NINE

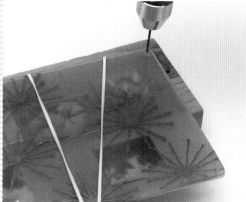

TEN

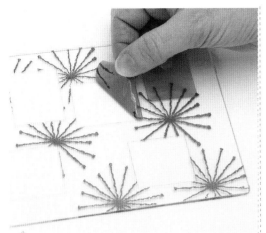

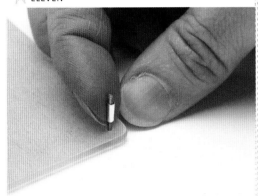

ELEVEN

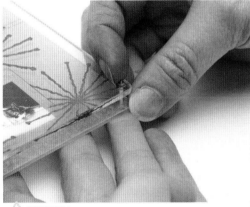

TWELVE

11›› Peel off protective covering

Peel the protective covering off of the back of the top piece of Plexiglas. Then, peel the pieces of the protective mask off of the front.

12›› Prepare to assemble frame

Push 4 screws up through the bottom of the piece of Plexiglas containing the photos. Slide a spacer bead onto each screw.

13›› Assemble frame

Place the top layer of Plexiglas onto the screws so it rests on the spacer beads. Finish by slipping a washer onto the top of each screw, then fastening each one tightly with a nut.

14›› Finish by adding hanger

Use epoxy to fasten a saw-tooth hanger to the back of the frame. You might want to center the hanger underneath a photo so that it can't be seen from the front of the project.

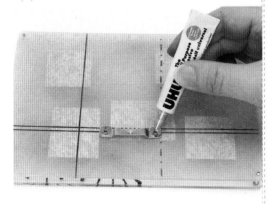

THIRTEEN

FOURTEEN

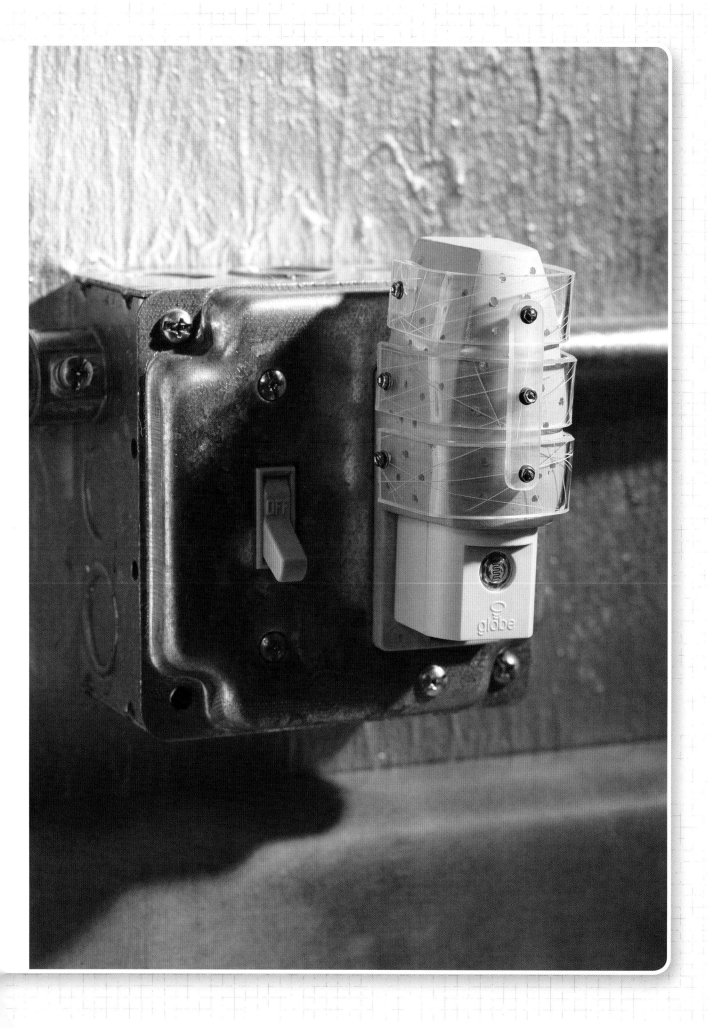

shadows in the nightlight

Store-bought nightlights typically lack personality, but their plastic covers make that easy to change. When you drill a few holes in the cover, it's easy to add any elements you wish. Spray paint, paper and embellishments are all optional decorations for this project, but insomniacs beware: You may like gazing upon your creation so much that you'll forget to go to sleep.

3 ⁵/₈" × 3½" (2cm × 9cm) Plexiglas strips

1 ³/₈" × 1⁵/₈" (1cm × 4cm) Plexiglas strip

store-bought plastic-covered nightlight

9 ¹/₁₆" (2mm) micro bolts and nuts

hand drill

¹/₁₆" (2mm) drill bit

fine-grit sandpaper

Dremel tool with sanding attachment (optional)

spray paint

silicone craft sheet

heat gun

plastic cutter

straightedge

fine-point pen

ruler

wire cutters

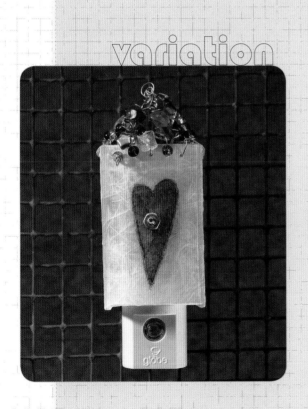

variation

Turn on your heart light, and let it shine!

1›› Sand nightlight cover

Remove the plastic cover from the nightlight. Use fine-grit sandpaper to sand the entire outside surface of the cover.

2›› Score and curve Plexiglas strips

Lay 3 strips of ⅝" × 3½" (2cm × 9cm) Plexiglas on your work surface and use a plastic cutter and a straight edge to score diagonal lines across each piece in a random pattern. Lay one of the pieces on a silicone craft sheet and heat it with a heat gun until it is pliable. Be careful handling the plastic; it will be hot. Use your fingers to form it around all 3 visible surfaces of the widest part of the nightlight base. (If your nightlight base is not the same size as this one, your plastic might need to be bigger or smaller.) Repeat with the other 2 pieces.

3›› Drill and paint nightlight cover

Randomly drill 1/16" (2mm) holes all over the surface of the plastic cover until you create an effect you like. Spray paint the plastic cover, and let it dry.

4›› Sand, mark and drill vertical strip

Use a fine-grit sandpaper and/or a Dremel tool with a sanding attachment to sand both surfaces and round the corners of the ⅜" × 1⅝" (1cm × 4cm) Plexiglas strip. With the 1/16" (2mm) bit, drill a hole in the center and at each end. Lay the 3 curved pieces from step 3 in position over the nightlight cover, and lay the small strip vertically across the center. Use a fine-point pen to mark through the holes in the vertical strip onto the curved pieces beneath. With a 1/16" (2mm) bit, drill through each of these marks.

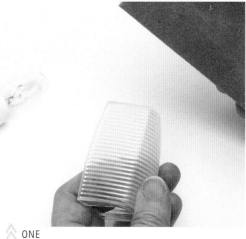

⌃ ONE

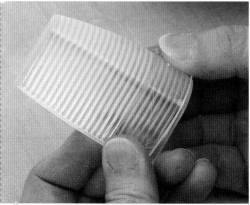

⌃ TWO

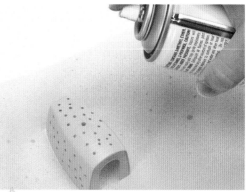

⌃ THREE

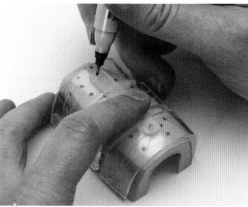

⌃ FOUR

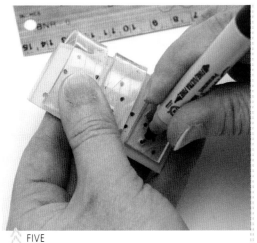

FIVE

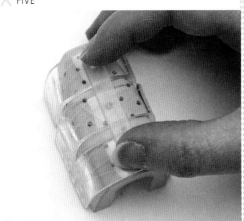

SIX

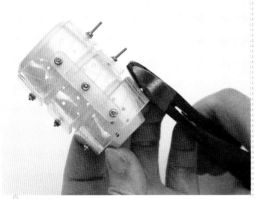

SEVEN

5›› Mark and drill sides of curved strips

Place the curved pieces back into position on the nightlight cover and measure the distance from the top of each piece to the hole you just drilled in the center. Turn the nightlight on its side. Measure the same distance from the top of each piece and make a mark at that spot about ¼" (6mm) in from the edge. Do the same on the other side. With a ¹⁄₁₆" (2mm) bit, drill through each of these marks.

6›› Mark and drill holes in nightlight cover

Place the curved pieces back into position on the nightlight cover. At each hole in the sides of the curved pieces, use a fine-point pen to place a mark at the location of the drilled holes onto the nightlight cover itself. Then, at each hole in the centers of the curved pieces, look to see whether or not the plastic is touching the nightlight cover underneath. (Here, the top piece protrudes higher than the nightlight cover rather than touching it.) Use the fine-point pen to mark through the drilled holes only where they are touching the nightlight cover. Remove the curved pieces and drill through each of the marks on the nightlight cover. Place the curved pieces and the vertical piece back in position over the nightlight cover, and make sure all the holes line up.

7›› Assemble nightlight

Use the bolts and nuts to attach all of the elements to the cover where the holes have been drilled. In any location where you determined in step 6 that the wrap piece was not touching the nightlight cover, simply bolt the decorative pieces to one another. Use wire cutters to snip the end off of each bolt as close as possible to the nut. Snap the cover onto the nightlight base.

The magic never ends! Here is some final inspiration.
I hope after trying some of the projects in this book
you'll be inspired to take Plexiglas to a new level!

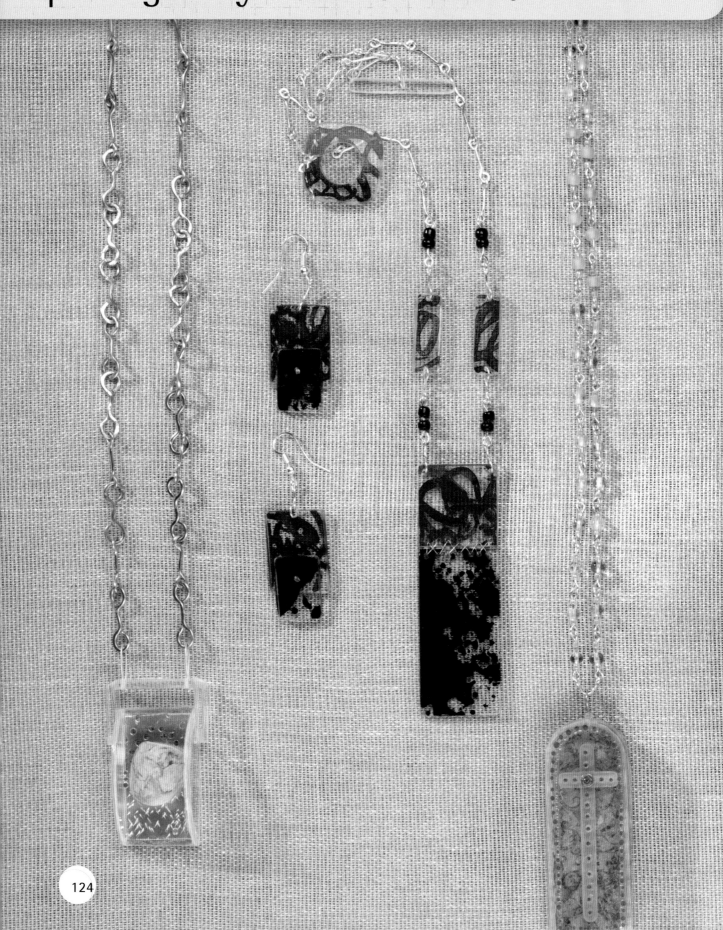

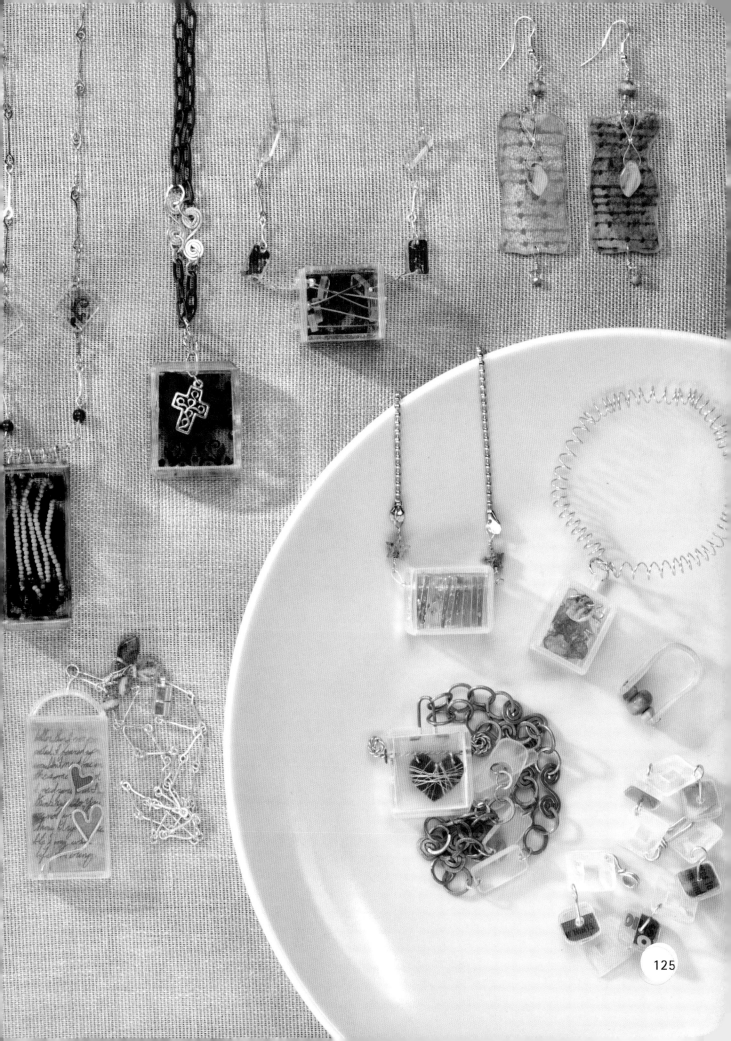

resources

Most of the supplies used to make the projects in this book can be found in your local craft, hobby, bead or discount department stores. If you have trouble locating a specific product, contact one of the supply sources listed below to find a local or Internet vendor or to request a catalog.

plastic
Plexiglas
Altuglas International
www.plexiglas.com

TAP Plastics
www.tapplastics.com

acrylite
Cyro Industries
www.cyro.com

Lucky Squirrel
www.luckysquirrel.com
PolyShrink shrink plastic

tools & hardware
Dremel
Robert Boch Tool Corporation
www.dremel.com
rotary tools and accessories

The Fletcher-Terry Company
www.fletcher-terry.com
handheld plastic cutter/scoring tool and framing point driver

Volcano Arts
www.volcanoarts.biz
snaps, micro-bolts and long eyelets

adhesives
Plastruct
www.plastruct.com
plastic weld solvent cement

UHU
www.saunders-usa.com/uhu
all purpose adhesive

ink and embellishments
Beadalon
www.beadalon.com
beads, wire and jewelry tools

Golden Artist Colors, Inc.
www.goldenpaints.com
acrylic paint and gel medium

JudiKins
www.judikins.com
rubber stamps

Stewart Superior
www.stewartsuperior.com
Super Marking Ink, Palette Glue Pad and Accent Powders

index

Take note of these other class acts from North Light Books

Frame It!
TONIA DAVENPORT

Learn how to create frames as special as your most cherished memories. Inside *Frame It!* you'll find simple instructions on how to use both ready-made frames and inexpensive framing materials to create frames that are perfect for your favorite photos, artwork or souvenirs. The book includes 20 step-by-step projects and a comprehensive guide to both traditional and contemporary techniques.

ISBN-10: 1-58180-688-4
ISBN-13: 978-1-58180-688-5
paperback, 128 pages, 33322

Bent, Bound & Stitched
GIUSEPPINA "JOSIE" CIRINCIONE

Collage, cards and jewelry with a twist! More than just beautiful step-by-step projects, there are techniques in this book that any aspiring artist will love. Among them are bending and shaping wire into letter and number embellishments, using a sewing wheel and acrylic paint to add texture to papers, adding dimension to cards with basic sewing, combining rivets and shrink plastic, reworking found objects into jewelry, and more. *Bent, Bound & Stitched* is one piece of eye candy you will want to pull off of your shelf time and time again.

ISBN-13: 978-1-60061-060-8
ISBN-10: 1-60061-060-9
paperback, 128 pages, Z1752

Semiprecious Salvage
STEPHANIE LEE

Create clever and creative jewelry that tells a story of where it's been, as metal, wire and beads are joined with found objects, some familiar and some unexpected. You'll learn the ins and outs of cold connections, soldering, aging, using plaster, resins and more, all in the spirit of a traveling expedition.

ISBN-13: 978-1-60061-019-6
ISBN-10: 1-60061-019-6
paperback, 128 pages, Z1281

Pretty Little Things
BY SALLY JEAN ALEXANDER

Learn how to use vintage ephemera, found objects, old photographs and scavenged text to make playful pretty little things, including charms, vials, miniature shrines, reliquary boxes and much more. Sally Jean's easy and accessible soldering techniques for capturing collages within glass make for whimsical projects, and her all-around magical style make this charming book a crafter's fairytale.

ISBN-13: 978-1-58180-842-1
ISBN-10: 1-58180-842-9
paperback, 128 pages, Z0012

These and other fine North Light titles are available at your local craft store, bookstore or from online suppliers, or visit our Web site at www.mycraftivity.com.